Impact of Nature Photography

Impact of Nature Photography

Richard W. Holzman

AMPHOTO
American Photographic Book Publishing Co., Inc.
New York

To my nature photography friends, I am grateful for their suggestions during the incubation stage of this book and especially to Kay Premo, Bob Carlton, and Bill Ahrens who gave critical comments on my manuscript.

All photographs by the author.

Library of Congress Cataloging in Publication Data

Holzman, Richard W.
 Impact of nature photography.

 Includes index.
 1. Nature photography. I. Title.
TR721.H64 778.9′3 79-20579

ISBN 0-8174-2476-8 (hardbound)
ISBN 0-8174-2147-5 (softbound)

Manufactured in the United States of America

Preface

Writing this book has crystallized my thinking about the photographic process as it relates to art and nature. When I started taking nature photographs, it was without any help or direction so that the results were very limited. Books gave little practical instruction or guidelines as to techniques, although a few are now available. Neither was I aware of composition until years later and then I had only a hint of the potential available.

This book is an effort to achieve *impact* by combining content, composition, and technique. All the ideas presented are based on practical experience which can be followed by anyone. You, the reader, now have an opportunity to learn about nature photography and avoid all the wasted time and mistakes that I encountered as a beginner. May these chapters be your inspiration to personal satisfaction through nature photography.

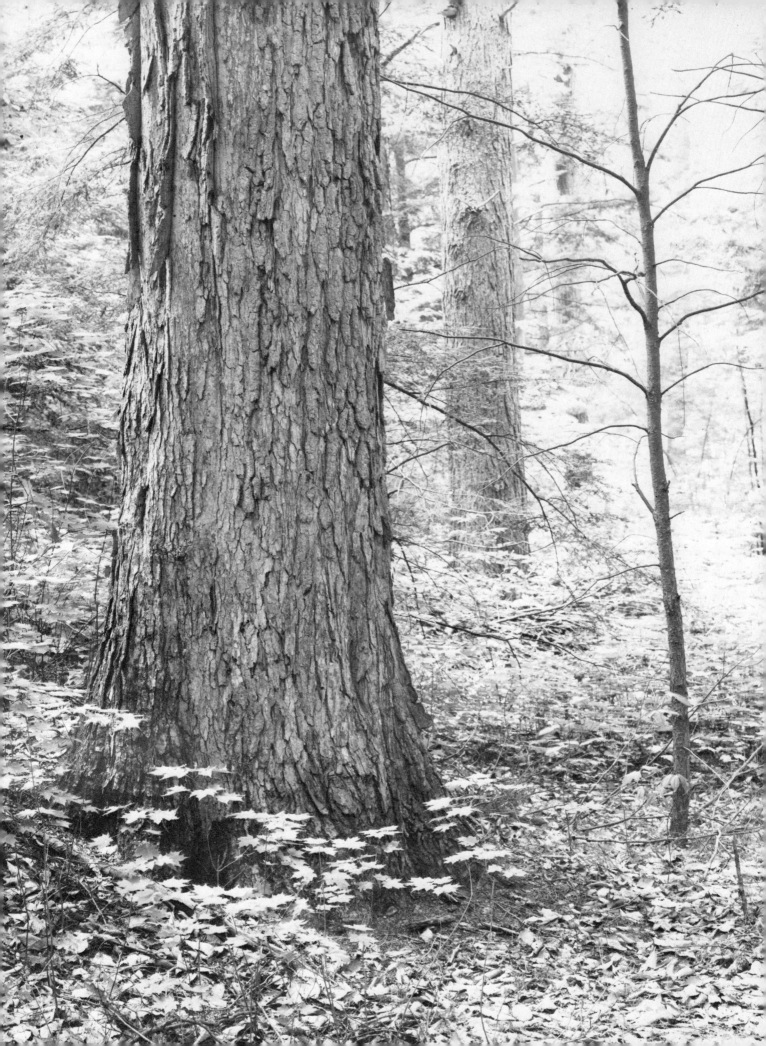

Table of Contents

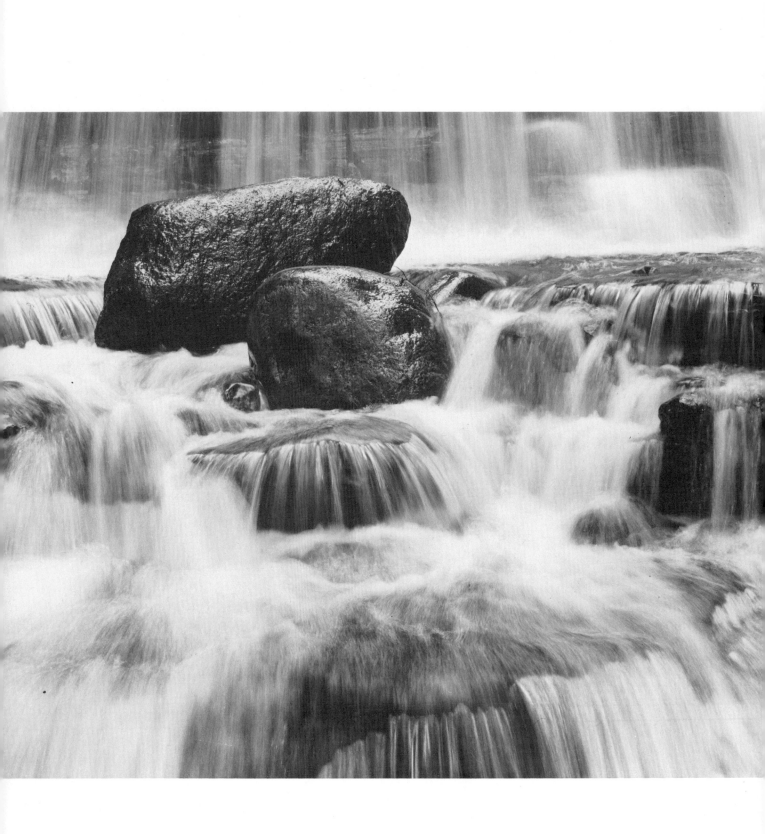

CHAPTER 1

Introduction

Everyone encounters photography in his daily activity through books, advertising, or magazines. Nearly every household has some type of camera, with color photography being preferred for gatherings, parties, or vacations. Because of the current awareness of the natural environment, many people are now becoming interested in photographing the nature that surrounds them.

Anyone with a few dollars can purchase a camera system and learn to use it, but nature photographers are often caught in a spiral of exotic equipment and technology. The photographic results may be technically good but lacking in artistic quality. The problem is that there are few publications that give the basics of making artful photographs.

What is art? It is creative work that has form and beauty. A great work of art has a quality, or personality, that holds and intrigues people from one generation to another. Although explaining the whys behind great art may be difficult, one thing is certain: Its radiance causes it to stand out for the enjoyment of all.

This book presents guidelines for the photographic artist who, using a 35 mm SLR (single-lens reflex) camera and color film, achieves impact by combining content, composition, and technique.

There are no complicated formulas or confusing charts. Only practical guidelines are given to help you start producing meaningful nature photographs. Most points are illustrated to help your photographic thinking.

You may wish to read quickly through the book to become acquainted with its content. On the second reading try to relate the different points with photographs that you yourself have taken. This will be especially important in Chapter 6, "Composition—the Second Element of Impact." Then take your camera and try to improve previous results with these newly learned guidelines. You may even wish to concentrate on one topic at a time—for example, center of interest—and expose one roll based on this theme.

Developing talent in nature photography will come only through practice. Hopefully, you will be able to equal the quality of the illustrations shown here and experience the joy of producing artful nature photographs.

◄ *Most beginners in nature photography are acquainted with the subjects they wish to photograph but have no fundamental knowledge of art. Aesthetics, the study of beauty, is the prime topic of this book.*

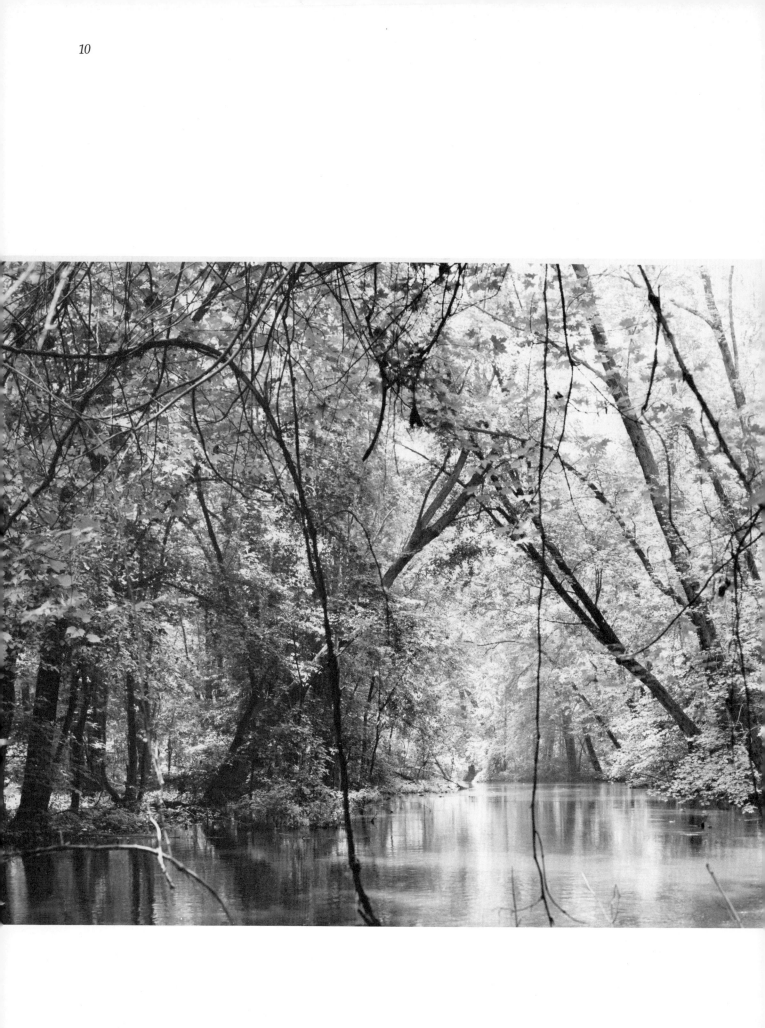

CHAPTER 2

Guidelines for Artistic Expression

In photography, which is one form of artistic expression, guidelines are important to a beginning photographer as a way of giving direction and helping develop talent. This is true in nature photography as in any other art form. The masters work with artistic instinct, but those of us more limited in ability seek the common denominators of successful work.

Some simple guidelines that have evolved form a starting point for artistic exploration. With practice these guidelines often become second nature and are used at the proper moment without conscious effort. However, absolute guidelines do not allow free artistic expression, and the occasional broken rule may be the element that sets a photograph apart from the others.

Comparing photography to painting is like comparing apples to oranges. Photography is a separate form of artistic expression; the only common denominator between a photograph and a painting is that a three-dimensional world is being represented on a flat surface.

Many masters used different mediums in their artistic efforts. The work of Leonardo da Vinci is timeless whether it be a painting, sculpture, or architecture. Had the photographic process been available to him, the resulting photographs probably would have displayed the same genius.

All the creative works of one artist cannot be considered great as there was a time of apprenticeship, a period of learning and experimentation. Later, the famous name may elevate the artist's obscure work into eminence. To say that the artist did not follow any guidelines on the basis of a few early works is not valid since all the artist's work needs to be seen and appreciated.

Some critics have stated that guidelines are not useful, referring to the fact that the master painters did not follow any. While this opinion may seem plausible to a photographic beginner, such direction is a disservice to photographic art.

◄ *Limitless opportunities in nature photography await those who wish to develop hidden artistic talent.*

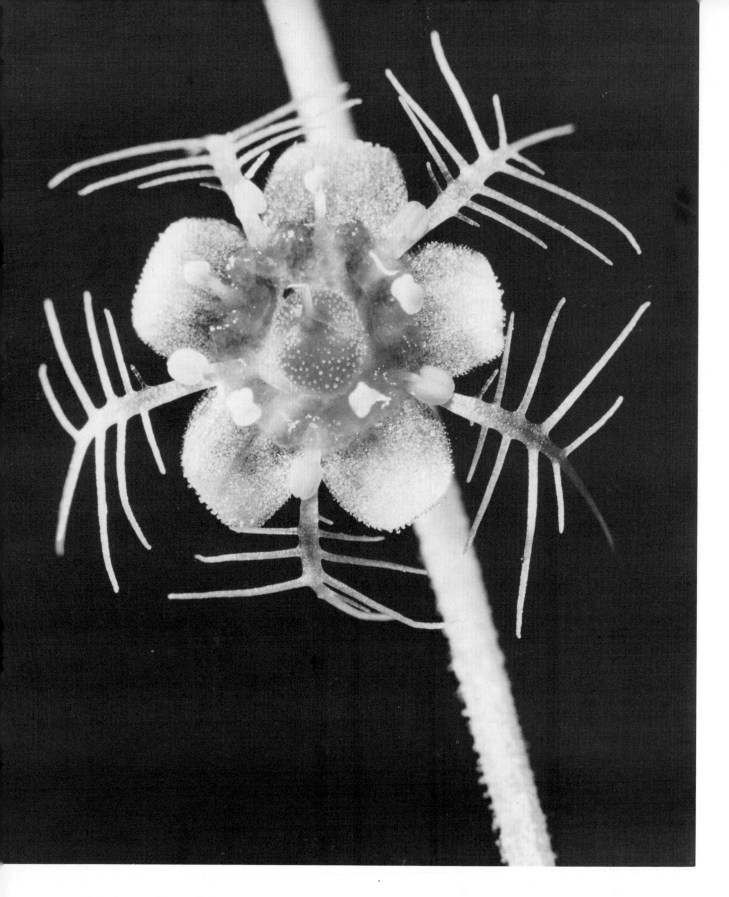

This miterwort flower, which measures only about 1/2 inch in diameter, is one of the smaller living organisms.

CHAPTER 3
Definition of Nature Photography

Nature photography records the facts and phenomena of natural history that occur in fields such as botany, zoology, geology, and meteorology. This is done in such a manner that the subject or theme is not distorted or contrived and identification of the subject is possible. Included as subjects are landscapes, seascapes, and a whole world of living organisms ranging in size from large to microscopic.

Evidence of man and his presence, which is summed up in the expression "hand of man," should not be visible. A nature photograph must show no cars, people, powerlines, telephone poles, litter, or other such evidence.

Domestic pets, hybrid plants, flower arrangements, mounted specimens, and museum habitats are not considered nature subjects; neither are photographic derivations and manipulations. Photographic "sandwiches," in which two different slides or negatives are combined into one image, should be presented in such a way as to be undetectable. Zoo animals are suitable nature subjects but the evidence of captivity should not be visible.

Do not let this definition of nature photography restrict your photographic expression and enjoyment. If the "hand of man" cannot be avoided, take the photograph anyway as part of your learning experience. You may like the result even though it is not, strictly speaking, a nature photograph.

The "hand of man" is not evident in this scenic.

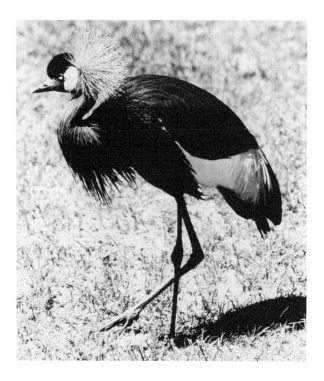

This crested crane at the Detroit Zoo was a cooperative subject. A 400 mm lens is recommended for most zoo animals in order to fill the frame.

The larva to this sphinx moth was found in August and reared to the adult stage the following June. Recorded here is a phenomenon of natural history.

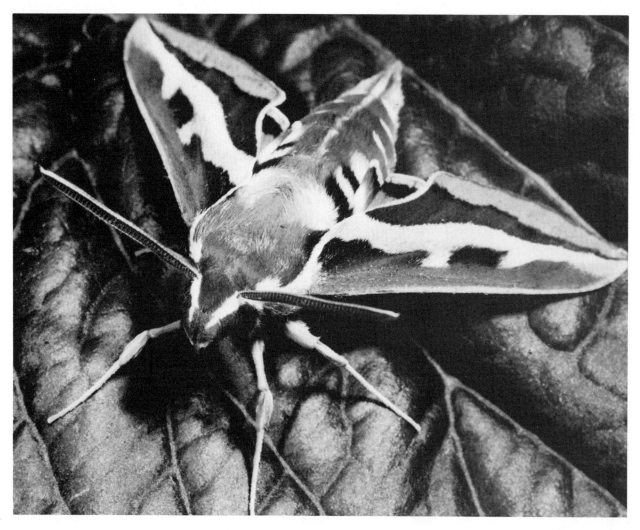

"Hand of Man"

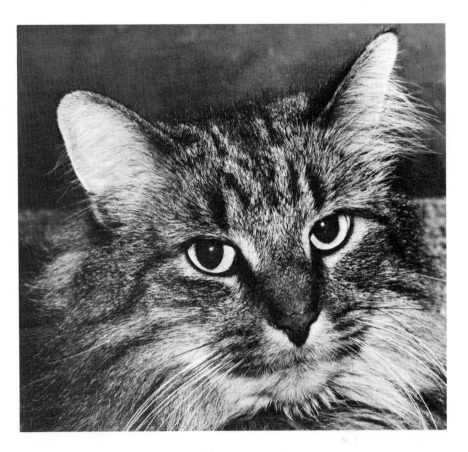

Domesticated animals are not considered suitable subjects for nature photography.

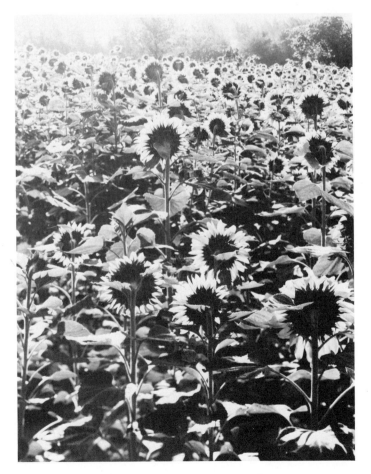

This field of sunflowers, which was planted by man, proved to be very rewarding photographically, but the result cannot be considered a nature photograph.

"Hand of Man" (continued)

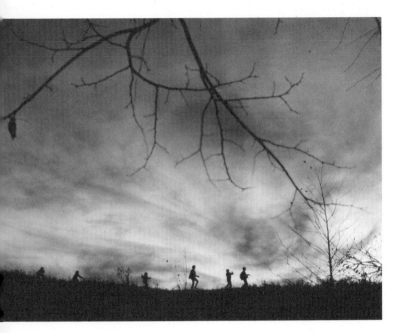

Without the line of children, this sunset scene had no real theme other than its colors. The children added a very definite emotion despite their being "hand of man."

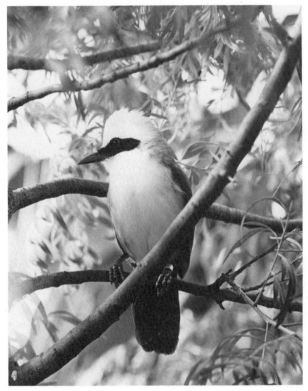

The metal band on the bird's leg should not automatically disqualify this picture as a nature photograph. The real problem in making the picture was to avoid the background of windows in the open aviary of the Detroit Zoo.

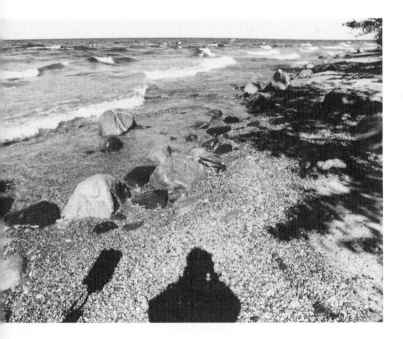

Shadows of the photographer, camera, and tripod keep this photograph from being a true nature photograph.

CHAPTER 4

Photographic Impact

Impact is the initial effect of a photograph upon the viewer. A successful photograph must create enough impact to interest and invite additional examination, since to be appreciated and to convey the photographer's message, it must be studied. A photograph with the greatest impact is one that gets immediately to the point. Like a poster that is bold and simple in design, it attracts attention.

Impact is achieved by combining three basic elements: content, composition, and technique. This order of presentation is the one followed during the photographic process—a photographer decides on content, arranges the subject components, and then makes the exposure. These elements are true for any type of photographic endeavor whether in nature, portrait, industrial, or general photography.

Content refers to how well the subject or theme fits the definition of nature photography presented in Chapter 3. Composition is the pleasing organization of the subject or thematic components. Technique is how the camera, lens, exposure, etc. were used to make the photograph.

It is difficult to assign a value to each photographic element since one may be more important than another under different circumstances. However, the following order of importance, from highest to lowest, seems to prevail: composition, technique, and content.

Achieving impact without composition would require very strong content and technique. Impact without technique would be less difficult to achieve if there were strong composition and content. The lack of significant content is not so disastrous when the composition and technique are strong.

There is little doubt as to what the subject is and what it is doing. This immature ring-billed gull has a simplicity that cannot be ignored.

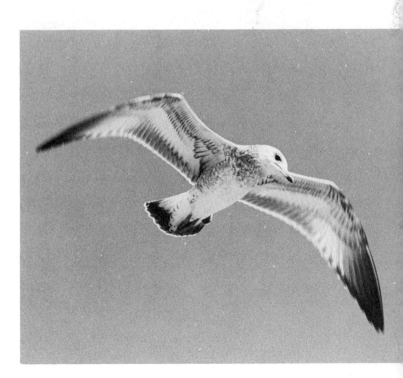

You might think, therefore, that technique and composition are of prime importance; this is a common myth among many photographers. To be a successful work capable of creating continued impact, a photograph must possess all three elements to the fullest possible extent. The hard part in achieving impact involves not so much recognizing each of the three elements, but finding the magic combination of all three. This is something only talent can determine.

All the lines of the spider web draw the eye into one point—the spider, which was a brilliant yellow.

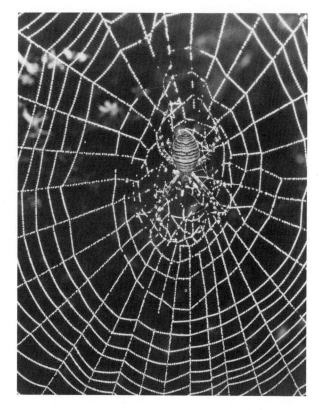

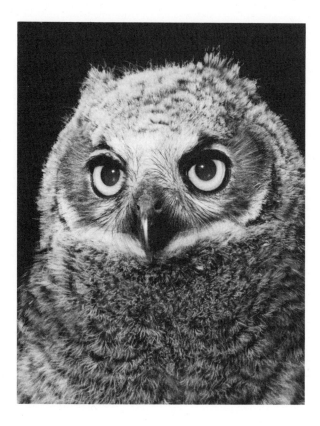

The brilliant eyes of the great horned owl draw the viewer's attention into the photograph.

CHAPTER 5

Content—The First Element of Impact

The content of a nature photograph deals with the subject or theme and how well it meets the definition presented in Chapter 3. The photograph should have nature significance, the "hand of man" should not be evident, and the subject should not be distorted or contrived.

The definition of nature significance varies among photographers but involves this basic question: Does the photograph reveal a meaningful phase of natural history or is it primarily pictorial? If it is entirely pictorial, it is not necessarily a good nature photograph, even though it might be of a nature subject. Nature photography has almost unlimited opportunities so that it is not very difficult to capture a nature experience.

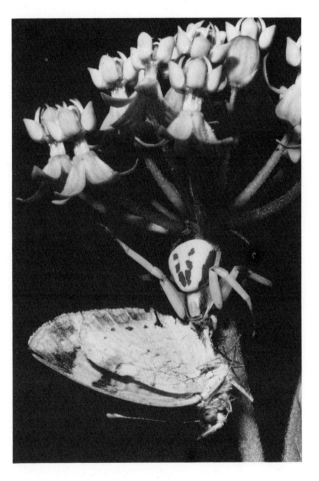

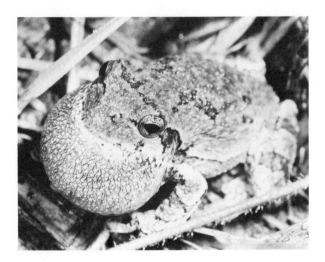

(Above) A crescent butterfly landed on the swamp milkweed flower but was attacked by a crab spider who was waiting for prey. Certainly this photograph, which shows the predator-prey relationship, has nature significance. (Left) The gray tree frog presents a more interesting and real-to-life subject when its vocal sac is inflated.

Content Including "Hand of Man"

The "hand of man" can manifest itself in different ways. There may be visible evidence such as powerlines in a landscape, aircraft vapor trails in a sunset, or human footsteps in the sand. There are subjects that to the beginner seem to be natural, but further consideration clearly reveals otherwise, for example: domestic animals, hybridized plants, or floral arrangements. Photographic examples of "hand of man" can be found in Chapter 3, "Definition of Nature Photography."

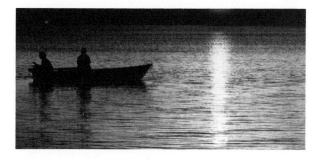

Walking a short distance to the right could have eliminated the "hand of man."

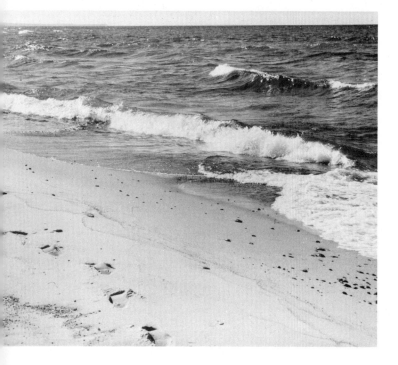

A heavy rain a few days earlier along an isolated part of Lake Superior resulted in a pristine beach until it was visited by a photographer.

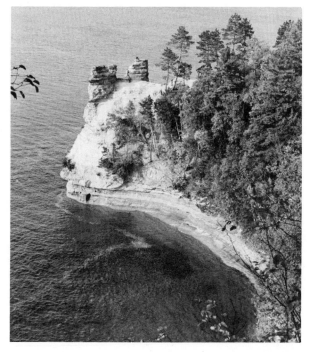

Although the "hand of man" is present (four people on top of the rocks), it is neither noticeable nor objectionable.

Contrived or Distorted Nature

Nature photography does not distort or contrive natural history. It avoids subjects that have been posed, that appear half dead from abuse in efforts to obtain the photo, or are obviously dead specimens placed in a suitable habitat. The knowledgeable person would recognize such photos for what they are. The subject, whether plant or animal, should be in a natural position and in a habitat of its own choosing.

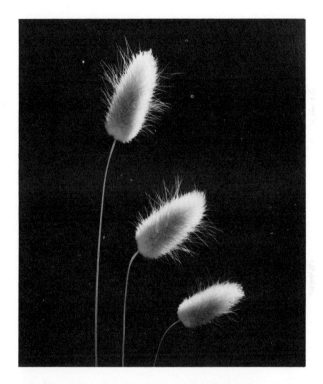

The subject here is strictly a pictorial display of the mature inflorescence or flowers of grass used in floral displays. Such pictures are often referred to as "basement shots" because that is often where subjects are arranged, contrived, and photographed.

The bat may seem natural at first but this photograph was made by holding the wings outstretched. The unnatural position of the wings is really a label to the fact that the picture is contrived.

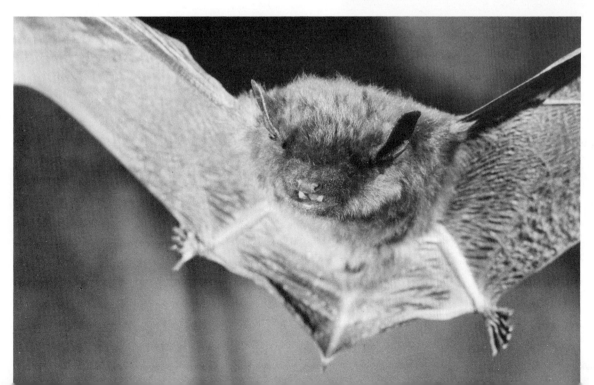

Contrived or Distorted Nature

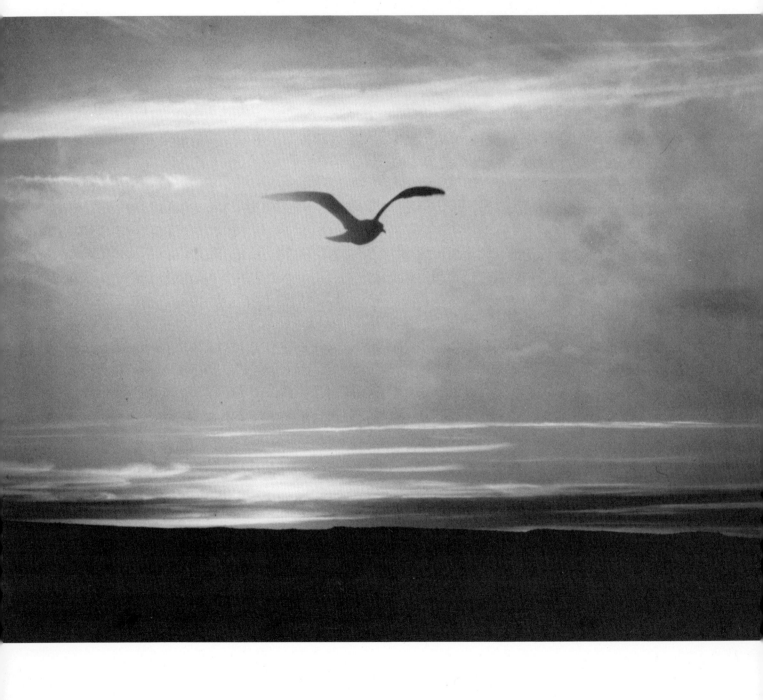

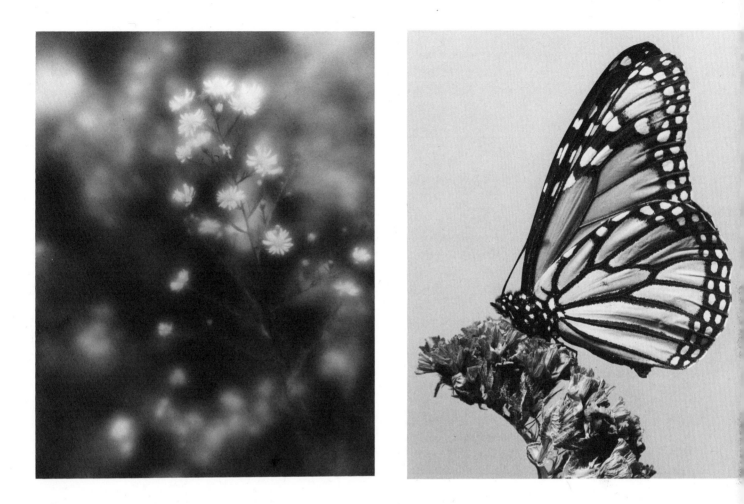

(Left) The extreme soft-focus treatment of the asters is very pictorial but not suitable in nature photography.

(Right) The dead monarch butterfly was placed on a dried flower. Note the absence of legs and the unnatural position of antennae.

◄ This is actually the result of two slides "sandwiched" together—one of a gull silhouetted and one of a sunset. Although the effort was contrived, the result appears to be natural, as if the photographer captured the bird just as it passed the sunset. If you are going to contrive a photograph, do it so it is not detectable.

Emotion in the Photograph

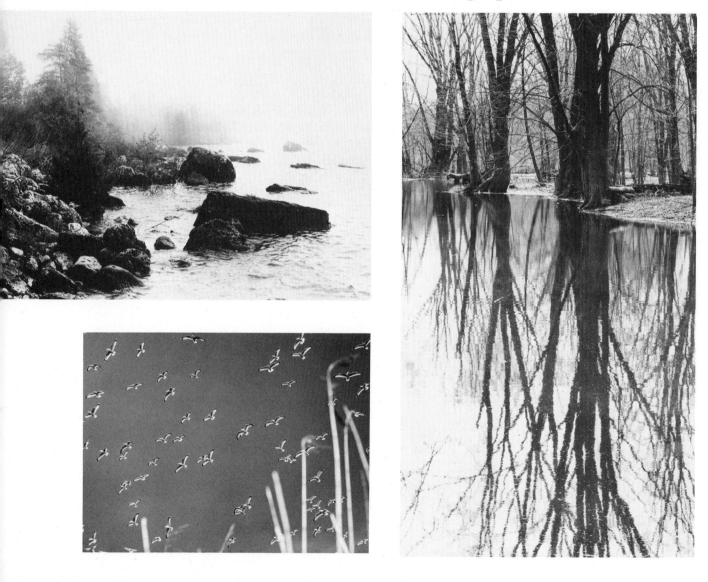

(Top left) Although this shoreline is rugged, the fog adds a sense of calm resulting in an emotionally pleasing scenic. (Bottom left) The deep blue sky and strong backlighting on the herring gull wings result in a very emotional photograph. (Right) Here, the many reflections create a feeling of serenity as the viewer's eye moves from top to bottom and front to back.

CHAPTER 6

Composition—The Second Element of Impact

The objective of composition is to create order from the disorder of nature by organizing picture elements into a unified whole.

However, complete order is monotonous. Variety is needed to form a pleasing design and elicit an emotion.

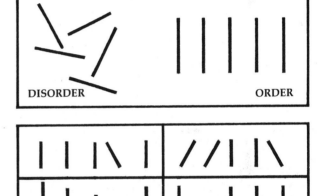

Here, bunchberry or dwarf cornel appear in an ordered arrangement.

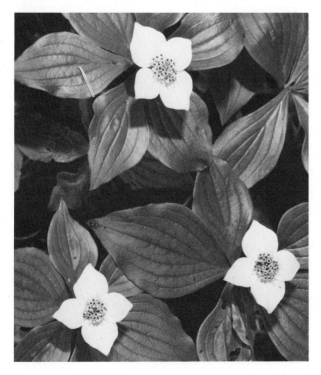

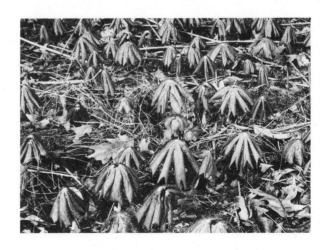

Fresh leaves of the mayapple are in complete disorder without any central theme.

Composition in nature is usually not apparent at first. The artist must search for a subject's hidden beauty, sense the design, and isolate the image. The pleasing arrangement of subject matter is based on one's past experience as an artist. The more you work with the subject or theme, the easier it is to recognize and isolate the composition.

Format Selection

The first step in composition is to establish the format: horizontal, vertical, or square. This selection is primarily determined by how the subject or theme fills the film frame. Some subjects just naturally call for a particular format while others might require experimentation. A horizontal format tends to give a feeling of expansiveness while a vertical format suggests a feeling of height. A square format, the result of cropping a 35 mm photograph, conveys a neutral feeling.

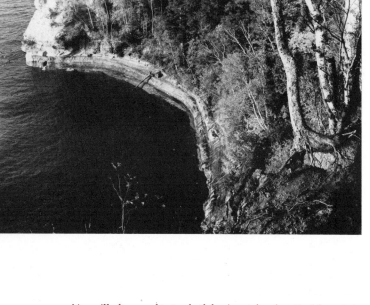

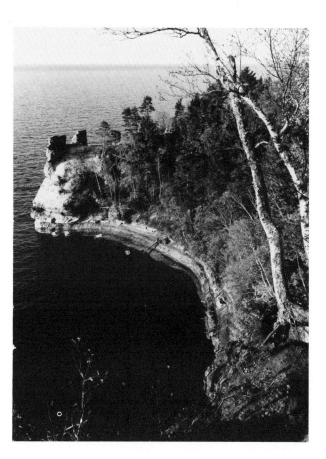

You will often need to try both horizontal and vertical formats to determine which is best. This is Miner's Castle along Lake Superior at the Pictured Rocks National Lakeshore in Michigan.

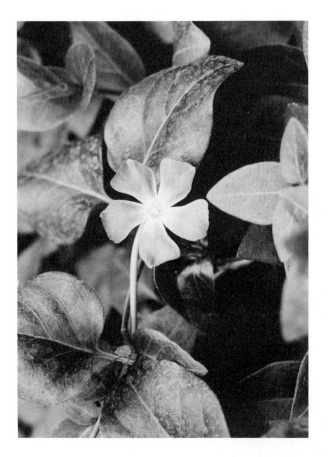

This single flower is lost among the leaves—only six percent of the total photographic area is occupied by the flower.

The swamp metalmark butterfly has a wingspan of less than one inch, but the frame is filled with subject matter.

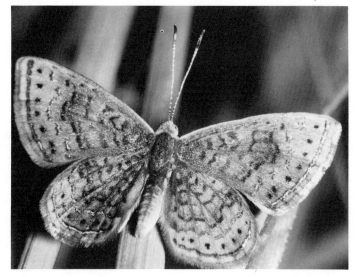

Filling the Frame

Whichever format is selected, the subject or theme should fill the frame. Make the entire photograph work for you by filling voids in the frame area with clouds, branches, shadows, or other naturally occurring objects.

However, do not let the main subject touch the edge of the frame. A closely cropped format has disadvantages. First, it does not allow the subject space in which to "move." This is particularly important when the illu-

sion of motion is desired. Secondly, it gives a cramped feeling resulting in a feeling of tension or discomfort. When filling the frame the extremities of an animal are sometimes cut off. This should be avoided because the feeling of incompleteness is disturbing.

In the extreme, the frame may be filled with just a portion of the subject so that the true character or identity is lost.

Filling the Frame (continued)

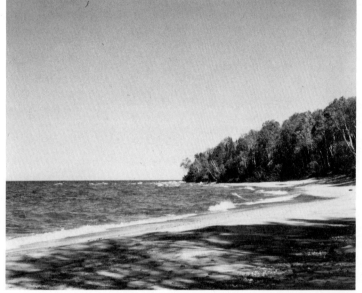

The blank open sky adds nothing to this photograph. Fluffy clouds would have helped, but that is usually a matter of luck.

Framing with a tree branch helped fill the picture area; something now appears in all parts of the photograph.

Overfilling the Frame

A close-up of the flower gives no clue to its identity; it is Stepalia gigantica, *which is shaped like a star and measures about six inches in diameter.*

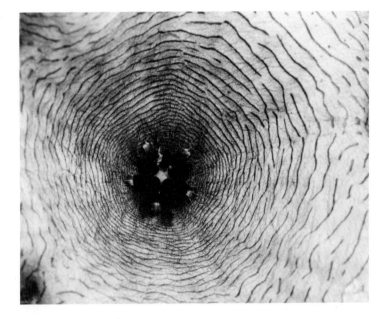

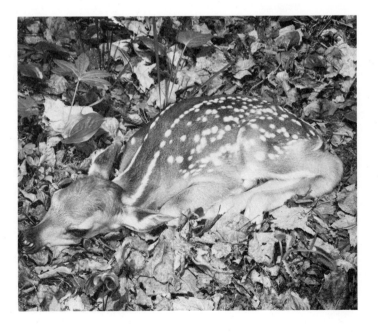

Cutting into the nose of the fawn is not desirable; check each part of the viewfinder so that none of the subject's extremities are cut off.

Center of Interest

A "center of interest" is often desirable since it gives the eye something to rest on and helps define the theme of the photograph. A "bull's-eye" center of interest may be tiresome because the photograph is too symmetrical. Putting the center of interest to one side creates a sense of activity resulting in dynamic composition.

One center of interest is desirable but if two such centers are unavoidable, subdue one by having it out of focus, darker, or smaller. With three or more, the same idea applies in that one should dominate the others.

The center of interest should be lighter than the background since the eye always goes first to the brightest point in the photograph. When the background is light, the center of interest is generally darker.

Another control is to have the center of interest the only sharp area of the frame. A blurred foreground or background will cause the eye to search for the sharpest point in the frame and stay there.

(Left) Two centers of interest (the bloodroot flowers) do not provide the eye any one place on which to rest; the eye goes side to side like a ping-pong ball. (Right) One center of interest is usually best. Here it is the immature ambush bug. The stamens are very subdued in relation to the bug and thus are not really distracting.

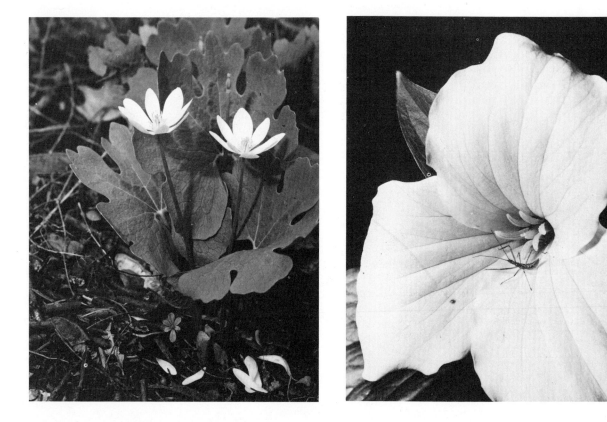

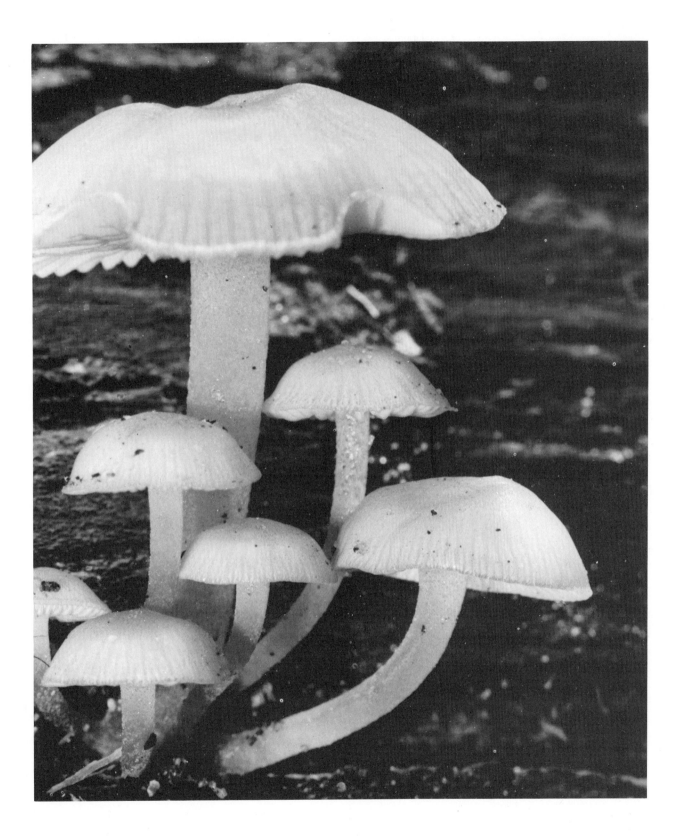

The largest mushroom of the group is the center of interest.

The "Golden Mean"

Much of ancient Greek art is based upon the proportion of 0.618 to 1, which is called the "golden mean." Examples of its use can be found in the Parthenon, and in vases and sculpture of the period. Its use was then abandoned until Leonardo da Vinci began using it in sculpture and painting. Recently, a psychologist found that the average proportion of thousands of common rectangular objects, such as windows, book covers, and playing cards, came close to the golden mean ratio. Of further interest is the presence of it in natural history, examples of which include the spiral of the chambered nautilus, the arrangement of sunflower seeds, and the location of leaves on a stem.

The golden mean can also be applied to photography. However, since the proportion 0.618 to 1 is difficult to use, you may wish to work with 0.666 or ⅔ to 1. This is achieved by dividing the frame into thirds both horizontally and vertically. The center of interest can then be at any of the four points of intersection.

A "golden mean" grid is constructed by dividing the frame into thirds, both horizontally and vertically. The center of interest can then be placed at any one of the four points of intersection.

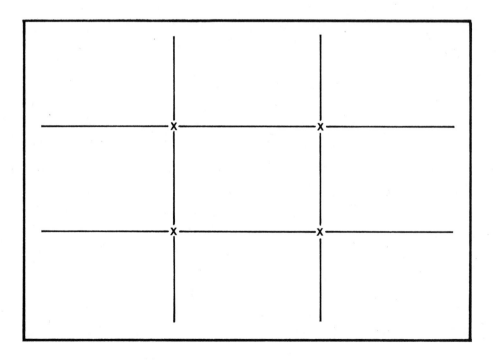

No matter where you look on the photograph, your eye returns to the right third.

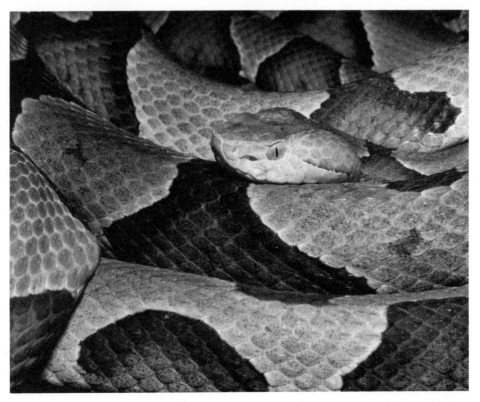

Although small, the eye of the copperhead snake is the center of interest.

The "Golden Mean" (continued)

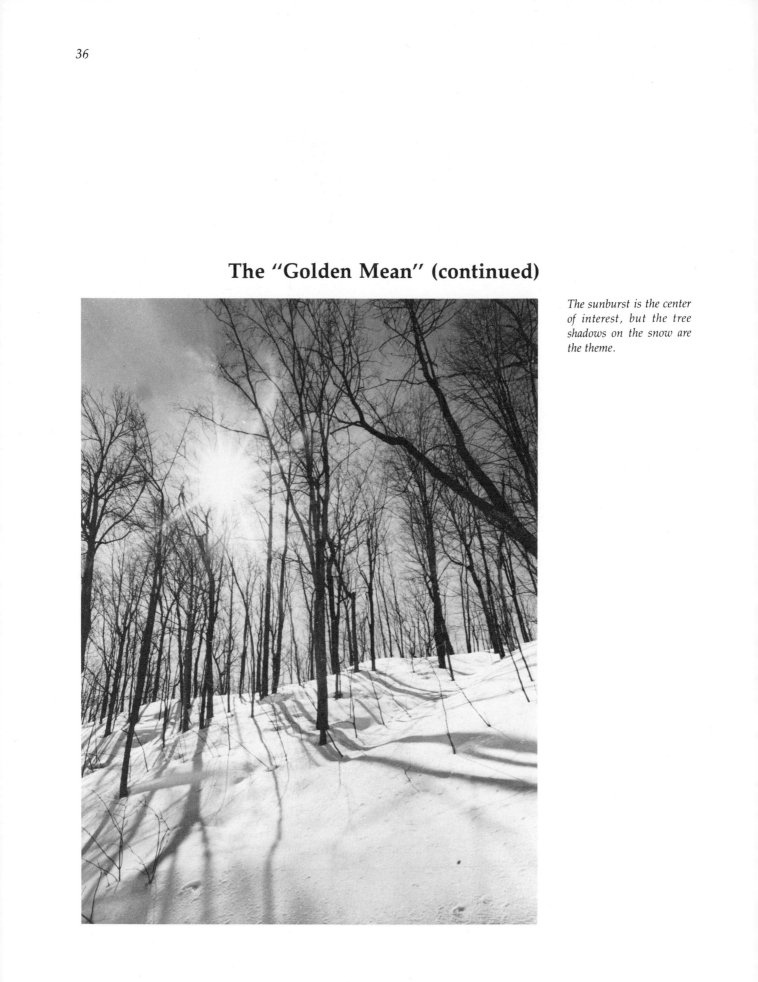

The sunburst is the center of interest, but the tree shadows on the snow are the theme.

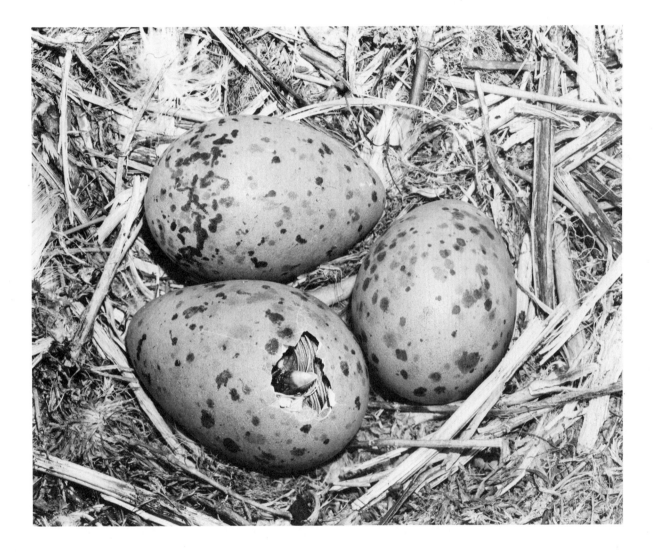

This herring gull chick pecking its way through the egg towards freedom carries a great deal of significance as the subject of a nature photograph.

"Bull's Eye" vs. the "Golden Mean"

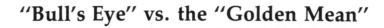

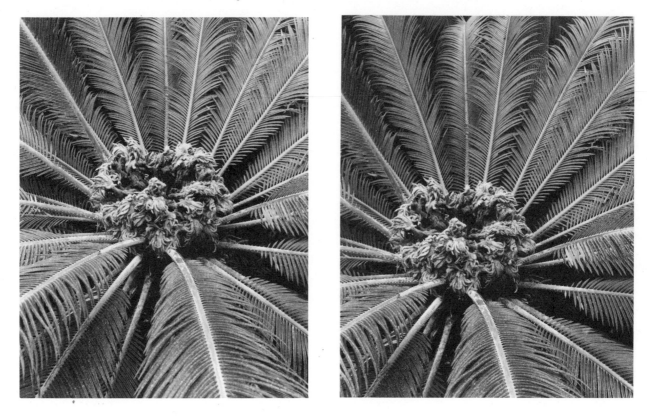

Shown here is a comparison of bull's-eye viewpoint (left) and "golden mean" placement.

The water line is at the upper third of the frame. Other compositional forces are the shadows on the sand and the curved shoreline. Use caution in lake photographs to keep the water level so that it does not appear to run downhill. ▶

The Golden Mean in Scenics

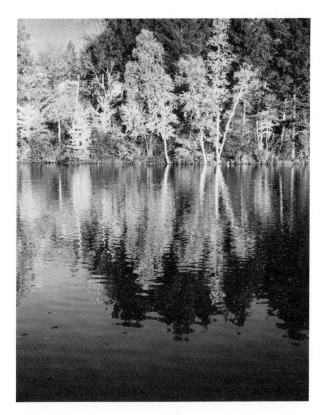

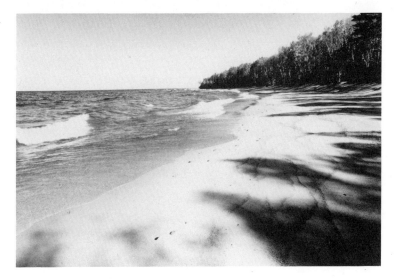

In the photograph on the left the "golden mean" applies to the horizontal division: the trees, top third, the reflection of the trees in the water, middle third, and the dark foreground water, bottom third.

In the photo on the right the maple tree divides the photograph vertically into thirds with the base at the lower horizontal third.

Design Potential

What compositional methods are possible when there is no center of interest? In this case, a photographer must isolate the picture elements, arranging them in a pleasing way through experimentation. For instance, you might arrange the elements to create:

A Straight or Curved Line

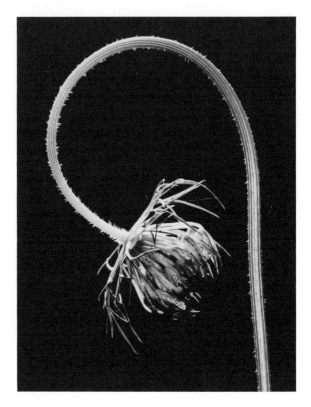

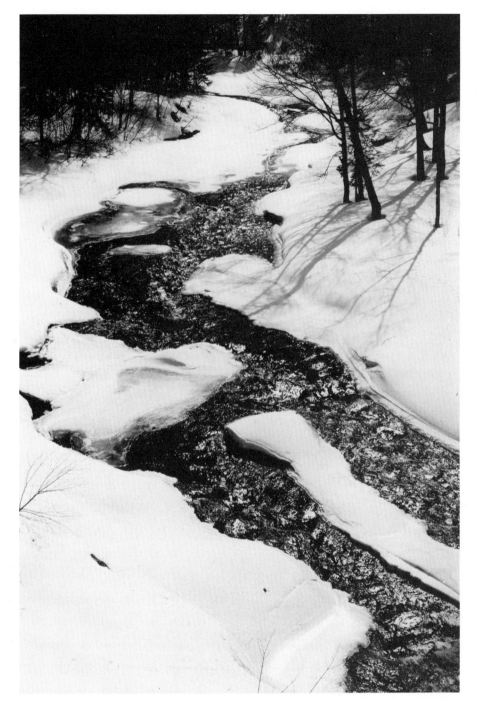

There is a tendency for the eye to follow the S-curve from front to back.

◀ Facing page: (Left) All objects along a part of the Lake Erie shoreline were coated with a thick layer of ice. (Right) Queen Anne's Lace or wild carrot has a graceful curve just before the flower is completely developed.

(Facing page) Shown here are the leaves of a young mayapple just before becoming erect.

Lines That Form Shapes

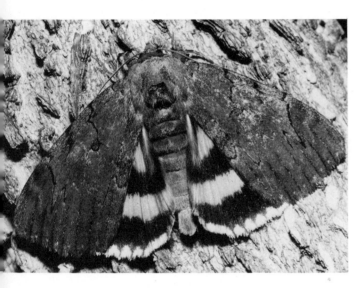

▲ *Normally well camouflaged, this underwing moth has brilliant red bands in the hind wings that make it easy to see when the wings are opened.*

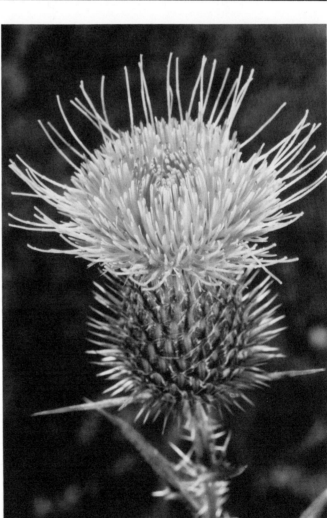

This reproduction does not do justice to the brilliant ▶ *magenta flowers of the thistle.*

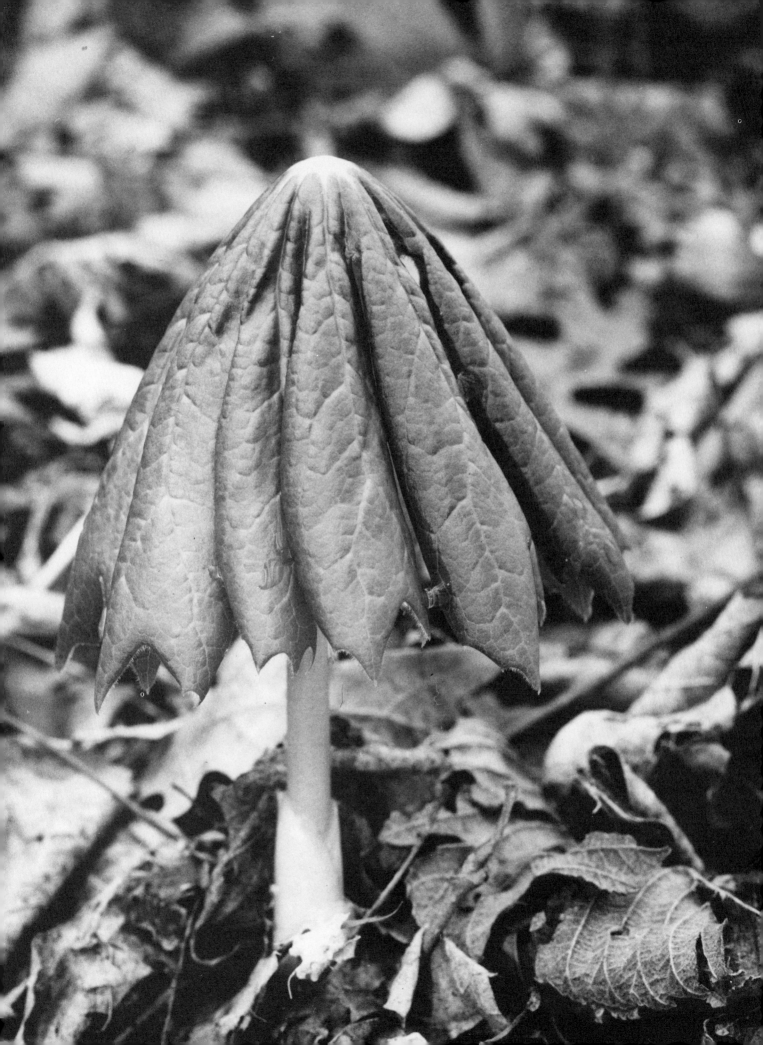

Lines and Shapes of Various Direction

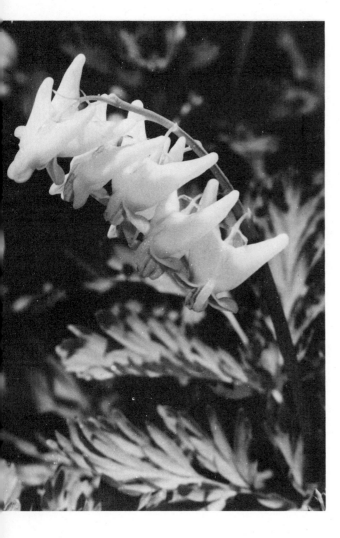

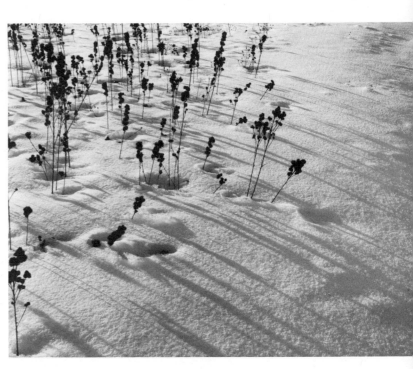

While the long shadows are the theme, the stalks give purpose and understanding to the shadows.

Diagonal placement of the subject results in a more dynamic photograph.

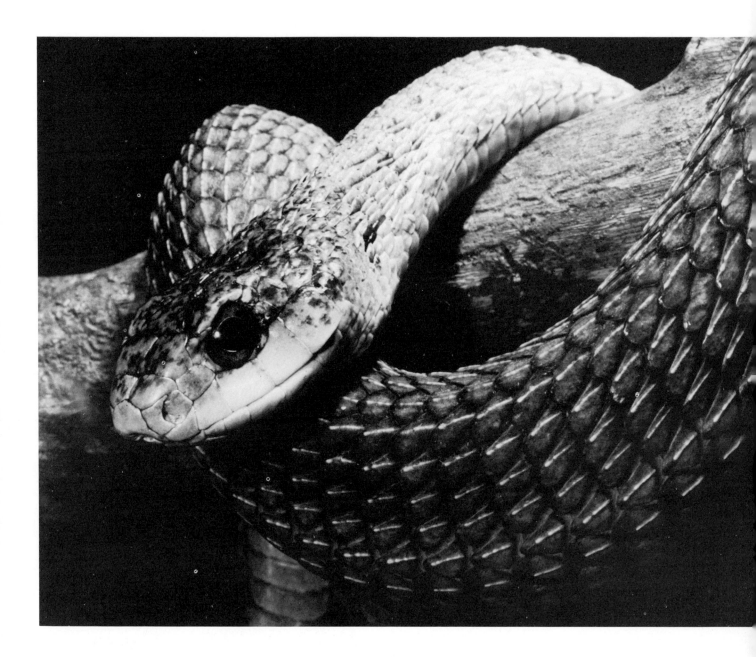

The diagonal coming from the upper right and ending with the
head results in the snake seeming to come out of the picture and
toward the viewer.

(Facing page) A radially symmetric subject has very powerful composition. The rain-covered leaves draw the eye into the "golden mean" position although there is no real center of interest.

Lines and Shapes Combined in Various Proportions

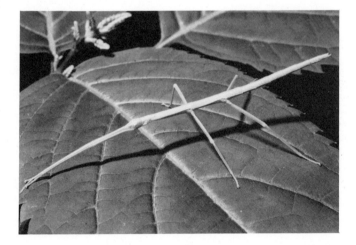

A walking stick has six legs and two antennae just like other insects. Note the diagonal placement and how the eye is at the third position.

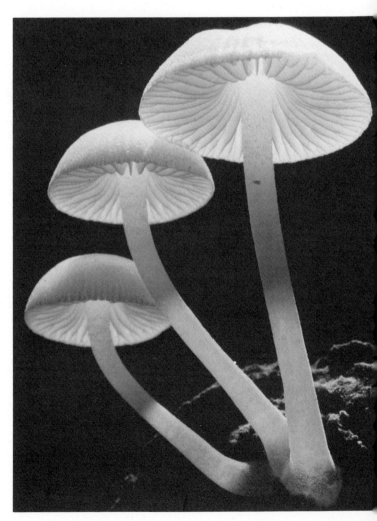

The mushroom on the right dominates the others in height and size.

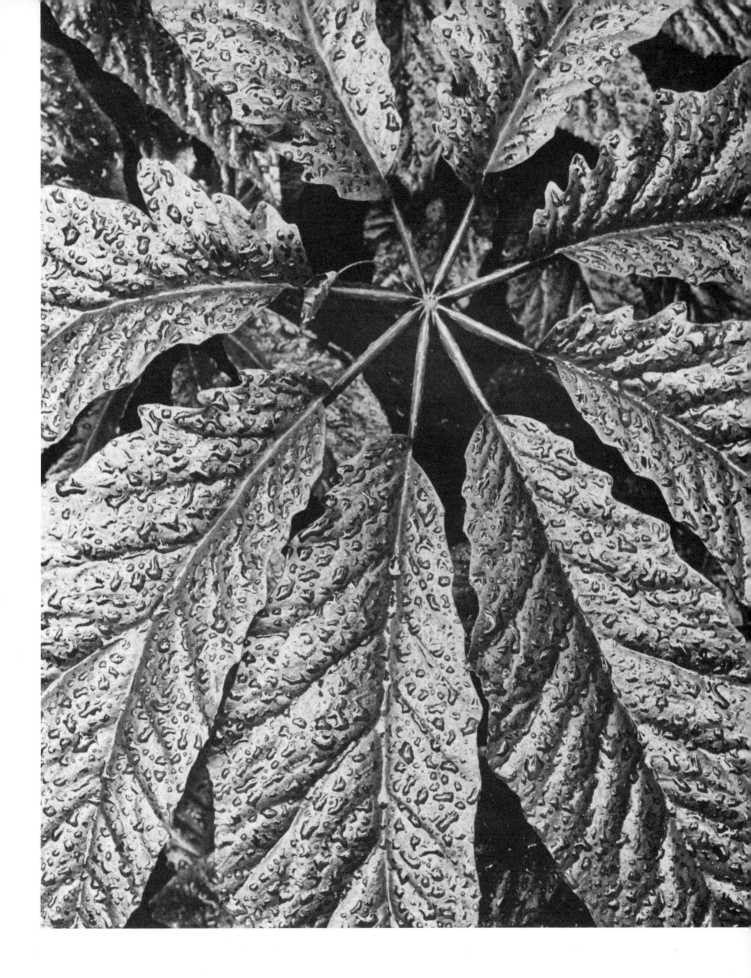

Texture, Pattern, or Rhythm

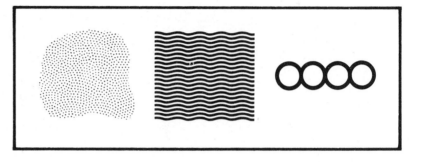

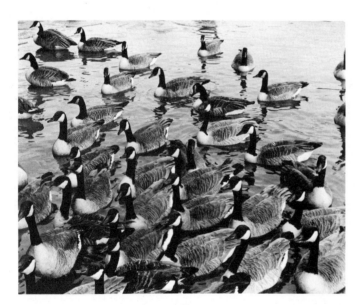

The heads of the Canadian geese are lined up in five vertical rows, creating a definite rhythm.

The ripples on the sand produce a strong rhythm with the bird tracks adding another type of rhythm.

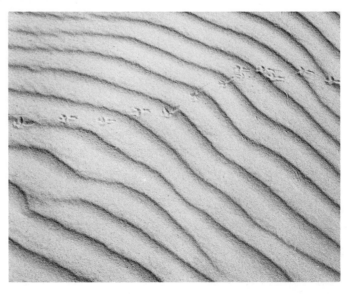

The random cracks here are interesting, but it is the texture of the cracked mud that adds a feeling to the photograph which is difficult to explain. After taking the photograph, the author touched the curled-up mud to see if it was real.

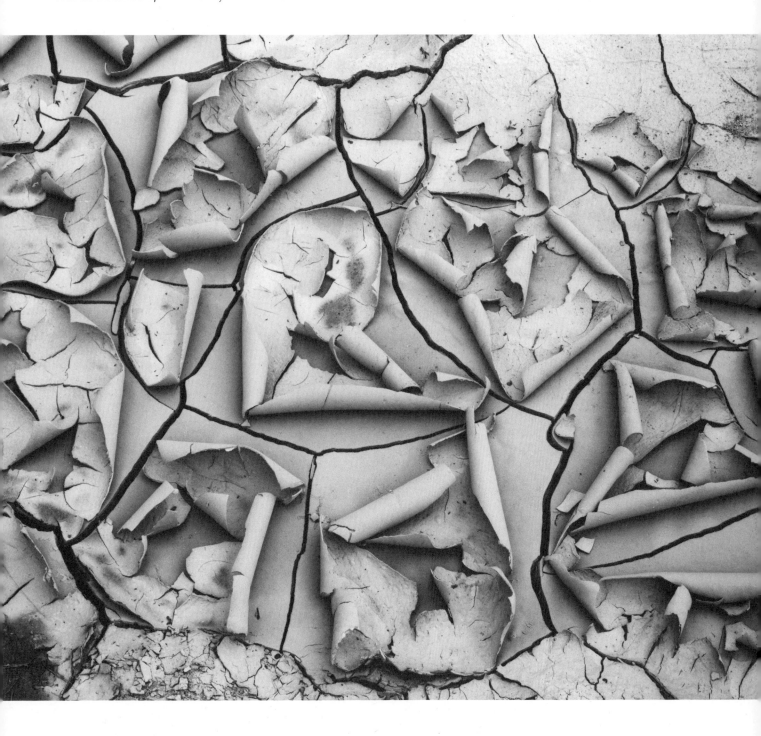

Perspective

In reality, spaces are perceived gradually as the eye focuses from front to back. A photograph does not allow this because the space differences are all on the same flat piece of film. "Perspective" is the illusion of distance or depth in a photograph and is a very powerful element of composition. A full awareness and appreciation of perspective is difficult to achieve unless you have access to lenses in a full range of focal lengths and can experiment with them.

When using a 20 mm lens, background objects seem smaller than normal, and foreground objects seem larger. On the other hand, a 200 mm lens causes both background and foreground objects to appear in their normal relationship. Thus perspective is recognized by the overlapping of planes, by the apparent diminishing in size of objects of known size, or the convergence of lines known to be parallel. Unless there is something in the foreground or background, perspective is not apparent.

If you could photograph a scene from one location using lenses of different focal lengths, you would find that the perspective does not change. The only difference between the photographs would be in the recorded size of the subject. A perspective change occurs only when the camera location is changed. By using a wide-angle lens and moving closer to the subject so that the subject is the same size as with the normal lens, you would render the background smaller but the foreground larger. The relationship of the background and foreground would not change as much if you used a long-focus lens and moved away from the subject.

With a 90 mm lens

With a 55 mm lens

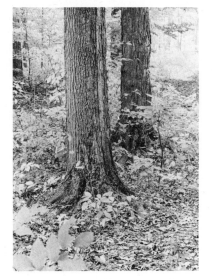

With a 20 mm lens

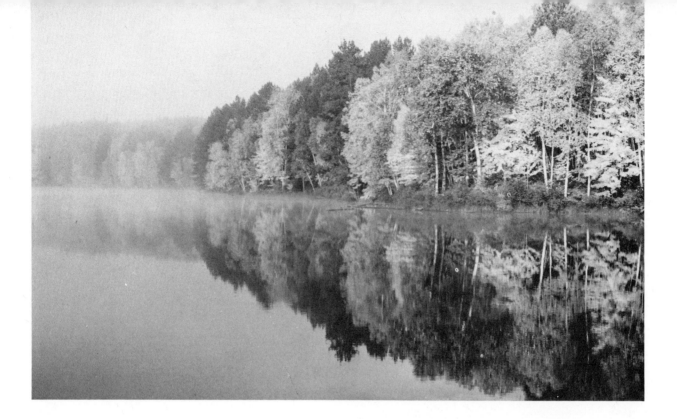

Perspective is also achieved by photographing the morning fog, which causes the trees to appear as if they were gradually fading away.

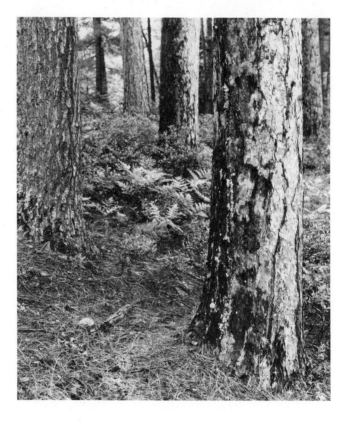

Not only do the red pine trees in the distance become smaller, but they also become increasingly blurred.

◄ *(Facing page) The camera was 20 feet from the first tree with another tree 10 feet further away. Without changing the camera position, 20 mm, 55 mm, and 90 mm lenses were used to photograph the two trees at f/11. Note that the coverage of the scene is drastically different when lenses of various focal lengths are used.*

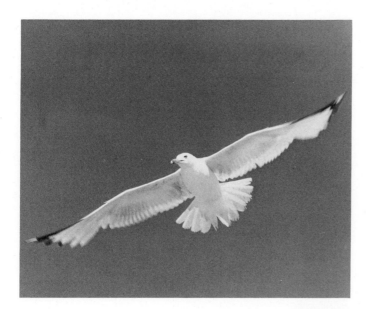

The blurred wing tips of the adult ring-billed gull confirm that the bird is moving.

Many nature subjects, such as aspen trees, are completely static.

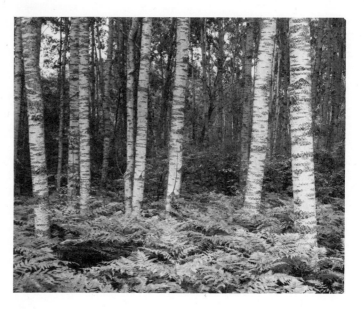

Illusion of Time

In literature or music, ideas are expressed in a logical sequence of time. A photograph, on the other hand, records only a "slice of time." Thus, any compositional device that gives the illusion of time and motion adds to the impact of the resulting photograph.

Diagonal placement of the subject creates a more dynamic photograph than horizontal or vertical placement. Having the subject on the left side of the frame can suggest action; also, having the direction of action going from left to right helps the subject appear more dynamic. This is because the eye is trained to read from left to right. The illusion of motion is helped by allowing space between the subject and the edge of the frame; this gives the subject "room to move."

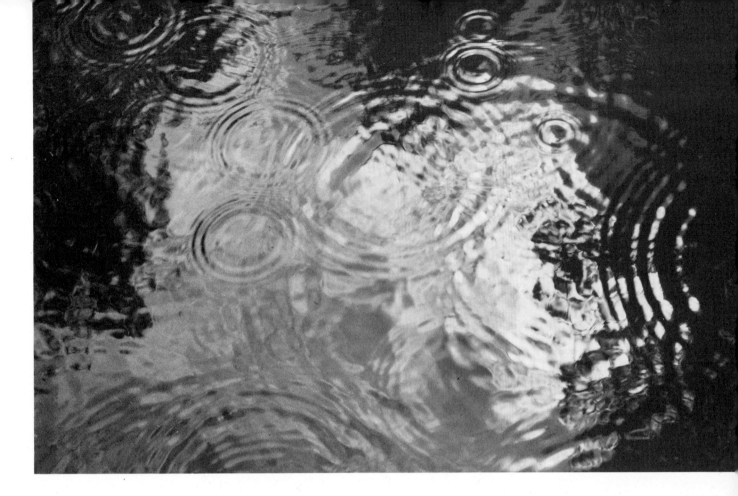

This "slice of time" has captured the effect of rain. The sun had
just come through the clouds after a thunderstorm; a few seconds
later, the rain finally stopped.

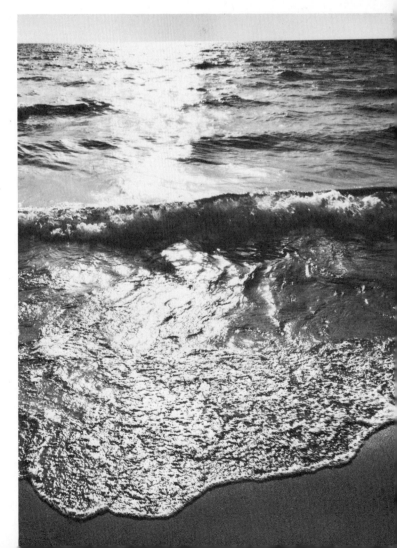

The slightly blurred wave is often better than a sharp wave that
appears frozen.

Viewpoint

A drastic effect on the subject's appearance is possible with a change in the camera viewpoint. Because eye-level is the point most commonly seen and photographed from, any variation appears more dramatic.

A "worm's-eye" viewpoint is perhaps the most dramatic because a low camera angle is somewhat out of the ordinary. Another important use of the upward view is to give the illusion of height, even though the subject might be as small as an inch-tall mushroom.

"Bird's-eye" viewpoint is an overall view that can range from a view of something underfoot to a look outward from a high point. This viewpoint tends to give a feeling of expansiveness.

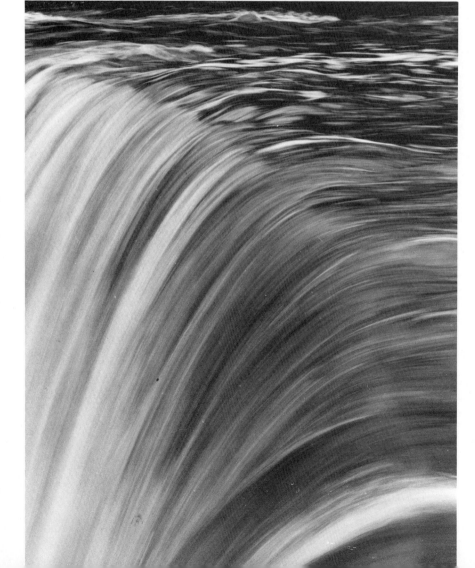

The eye starts at the top of the waterfall and then quickly follows the water downward.

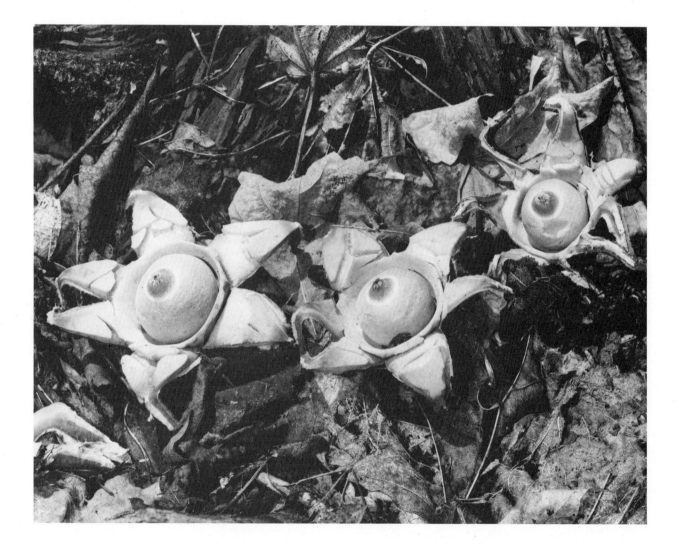

A bird's-eye view is one way to show the symmetry of the earth-star fungus.

Eye-Level View

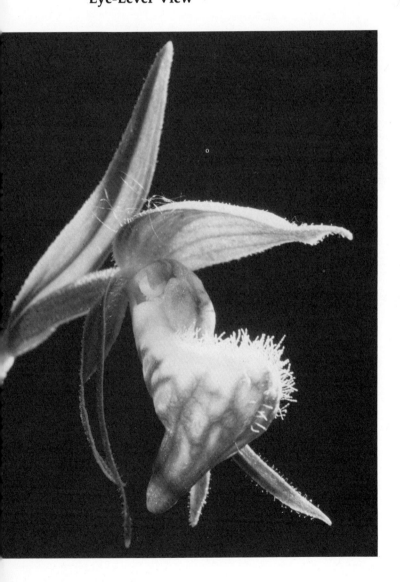

The ram's-head lady's-slipper orchid as seen from the side reveals the shape that gives rise to the plant's name.

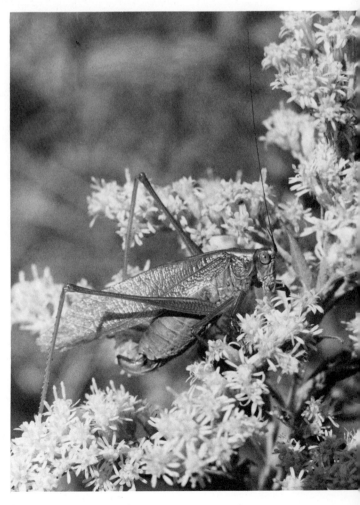

The katydid is photographed from the side in order to keep the entire insect in focus.

Worm's-Eye View

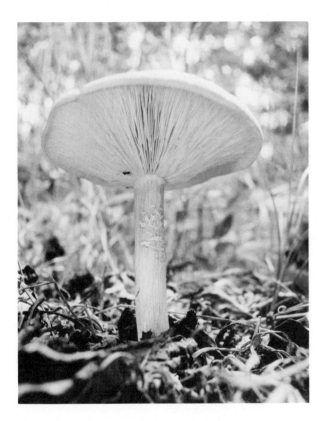

The camera was positioned on the ground to photograph this five-inch tall mushroom with a wide-angle lens. Mushrooms are usually seen from a bird's eye view so this treatment draws attention.

These large-toothed aspens were taken with a 20 mm lens.





Background

The background should be subdued so as not to distract attention from the subject or theme. The eye of the viewer should be drawn into the photograph and onto the subject or theme.

Objects or colors that merge into the subject are very distracting. A background with bright spots or one white corner competes with the subject for attention. The eye is always drawn to the brightest point in the photograph. Unless that bright point is the subject or center of interest, it is a distraction that reduces the quality of the composition.

Control of the background depends on the careful use of compositional methods such as the following, which have already been mentioned:

- Perspective to make the background appear larger or smaller than normal.
- Viewpoint that will change the background.
- Background that is darker than the subject.
- Filling the frame with the subject, thus reducing background.
- Background completely out-of-focus with subject in focus (selective focus).

Achieving background control is covered in Chapter 7, "Technique—The Third Element of Impact."

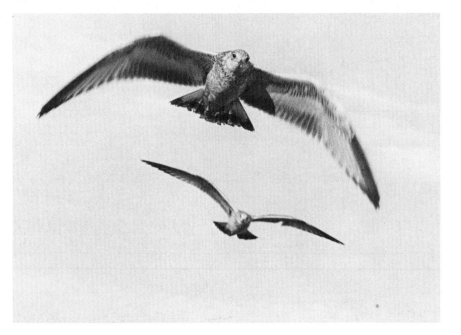

A neutral background without distractions emphasizes the ring-billed gulls.

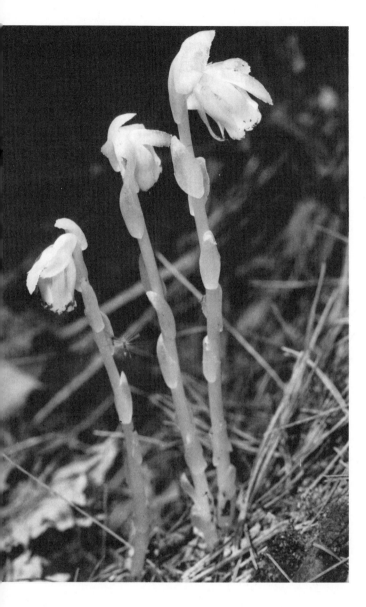

The Indian pipe flowers, which are at their prime, show clearly against a neutral background.

Mature Indian pipe plants are lost in the confusion of the background.

(Facing page) Everything is in sharp focus but the two smaller ▶
trees do not compete with the large maple tree.

Background (continued)

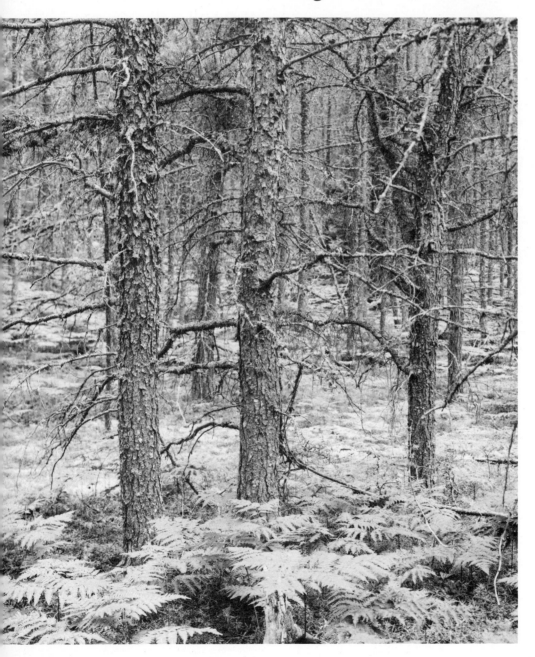

*Too many jack pine trees result in
confusion; using selective focus
and isolating a few trees would
have helped.*

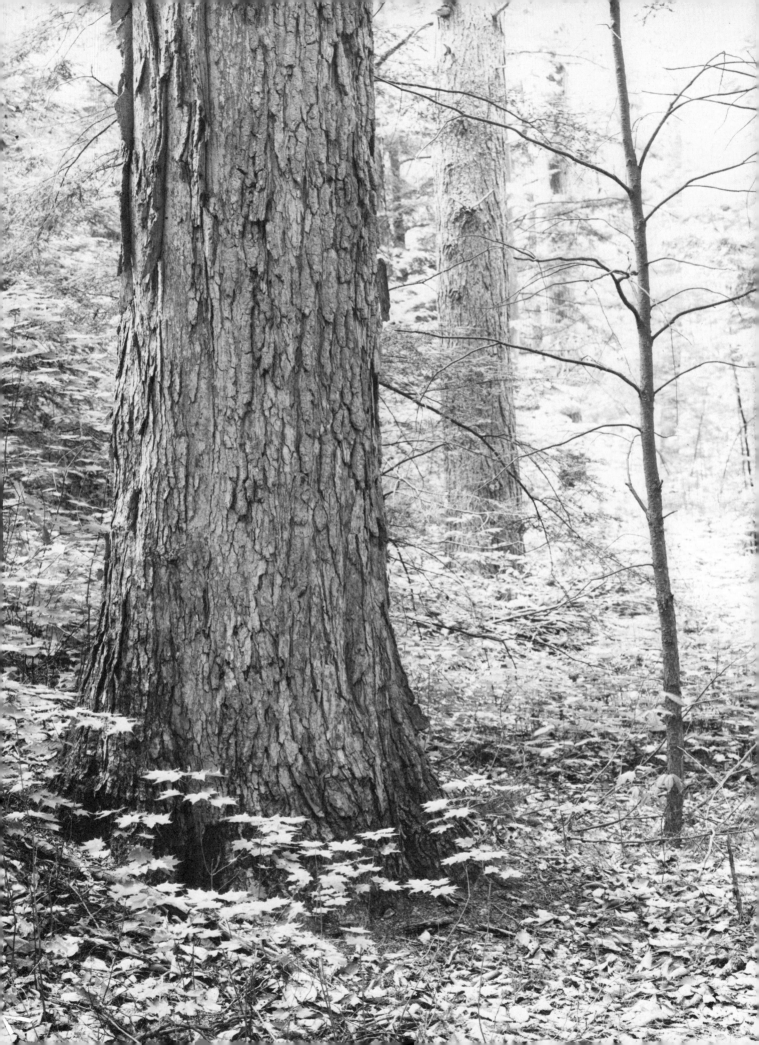

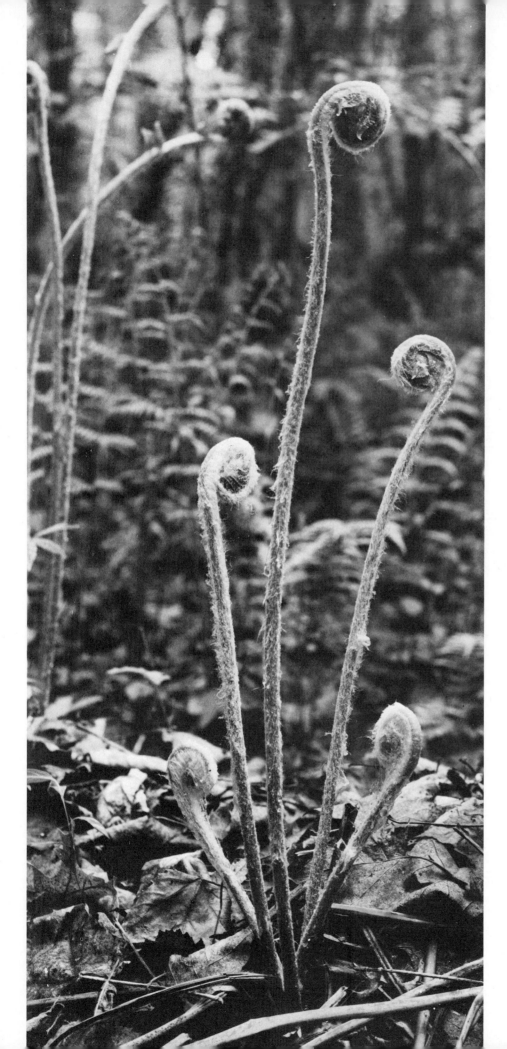

Selective focus of these fern fiddleheads at f/4 resulted in the background being out-of-focus.

Color

In nature photography, selection of the subject color and background color is usually not feasible—you photograph what is at hand and make the best of the situation by controlling lighting, viewpoint, and perspective.

A situation that has a full spectrum and scale of intensities will usually result in a color slide with greater interest and emotional appeal than a monochromatic (one-color) slide. A slide with complex composition will often be enhanced by the use of simple colors, while one with simple composition may be able to accommodate a complex color scheme.

The importance of color in nature photography is not really evident until the same subject is photographed in black-and-white. Then suddenly problems arise with background mergers, dull subjects, and lack of tonal separation. A successful black-and-white nature photograph demands a full awareness and execution of composition and technique.

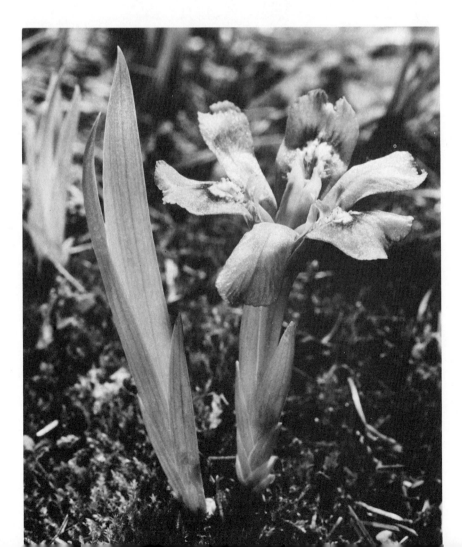

This violet flower and these green leaves contrast for a very dramatic color photograph, but in black-and-white this combination is only moderately successful.

(Following page) The blue sky ▶ and greenery of the desert make a successful photograph in both color and black-and-white.

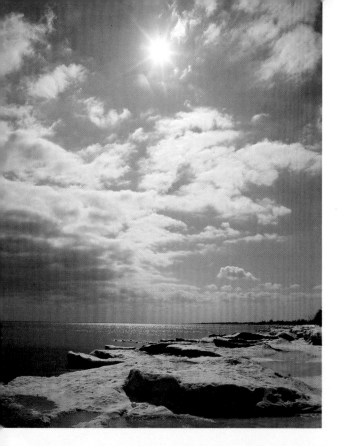

The brightest part of this photo is the focal point along the creek. ▶

(Left) Use of a wide-angle lens stopped down all the way resulted in the sunburst. Slight underexposure kept detail in both the snow and the clouds, photographed along Lake Huron, north of Port Huron, Michigan.

(Below) A dense growth of wild geraniums is without order except for a lone tree at the ⅔ position.

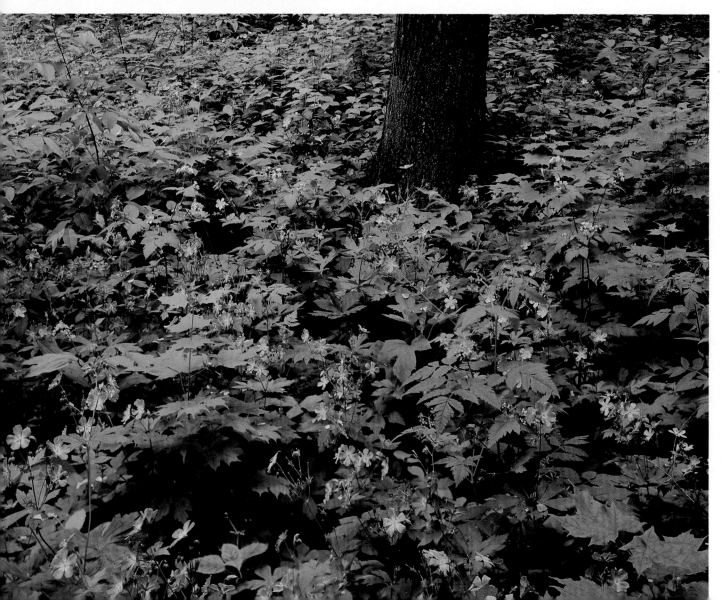

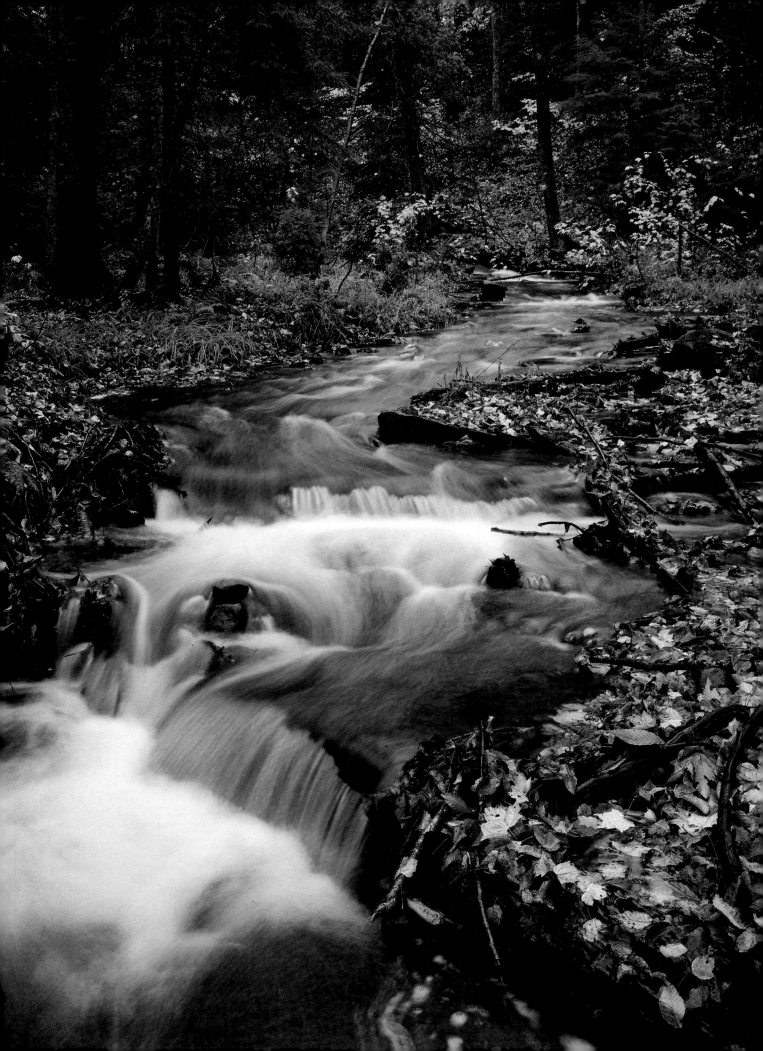

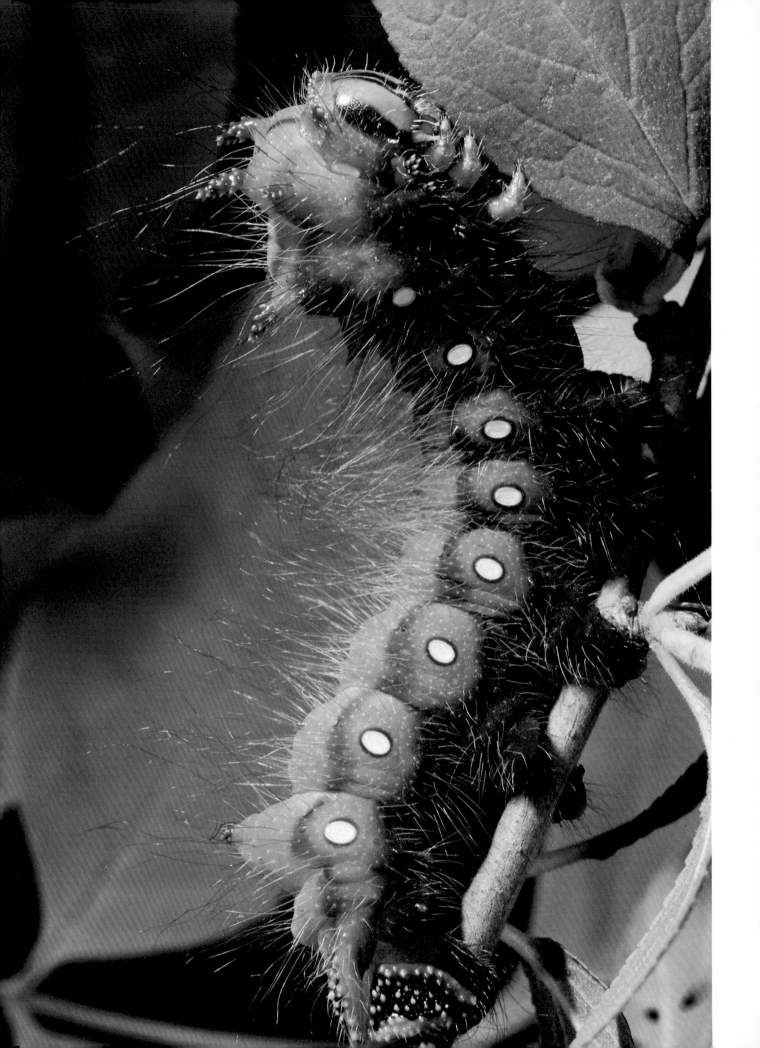

◀ *The gentle curve of the Imperial moth larva is what makes the composition in this close-up photo.*

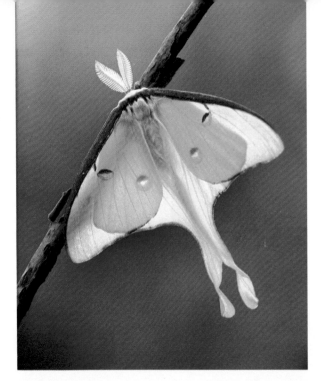

(Right) The Luna moth was backlit by an electronic flash; morning sun served as fill light.

(Below) The eyes of the fly measure only ¼" wide — an example of a common nature subject that is completely different when seen close up.

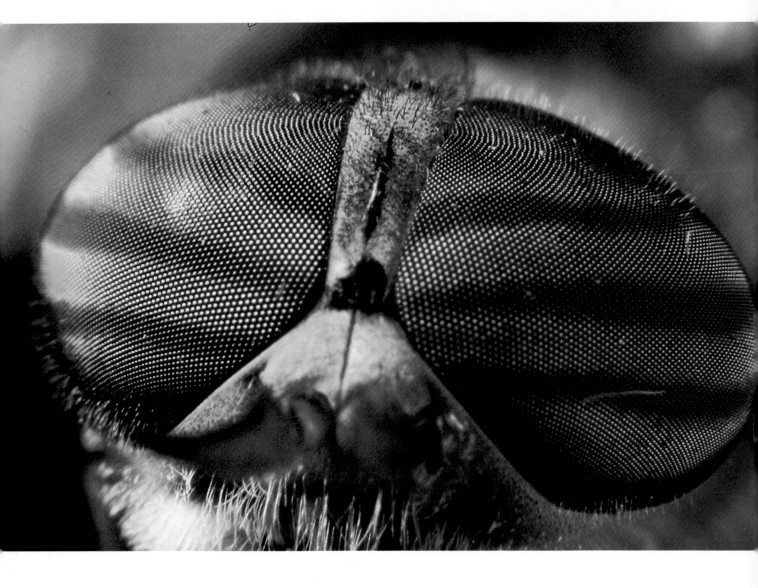

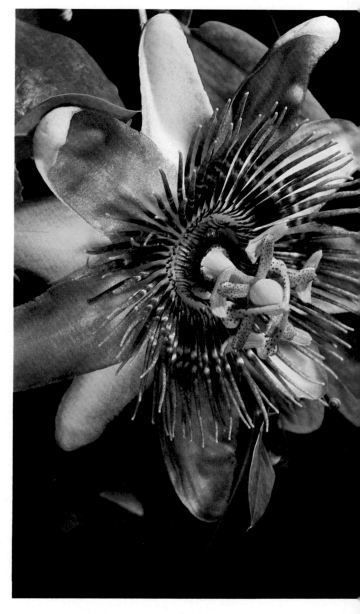

(Above) The passionflower has a most delicate structure that is a challenge to photograph. When examining a flower, look at it from all views to discover and maximize composition.

(Left) Impact was obtained in this photo by the brilliant color and placement of the three flowers.

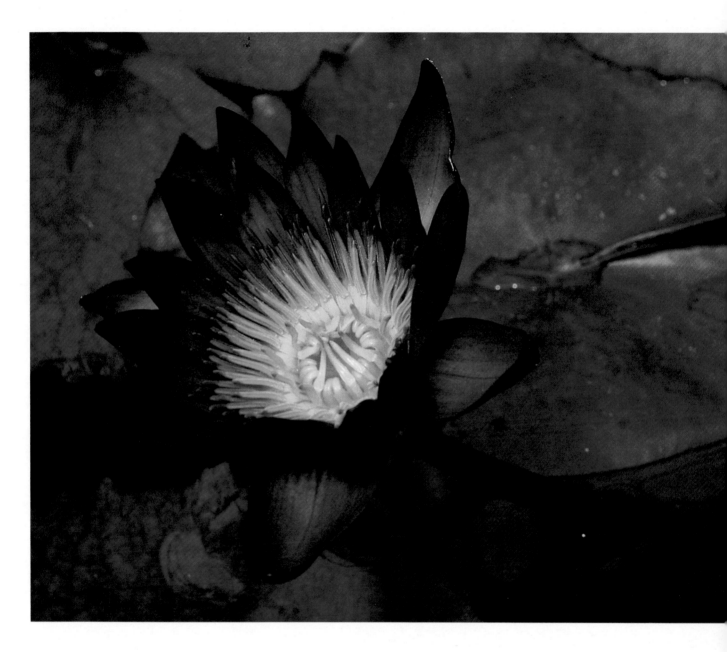

The eye is immediately drawn to the yellow, which is the lightest area in the photo and at a ⅓ position.

(Next page) Although this is a very static scene, it has a ▶ presence that makes the viewer want to walk into the frame.

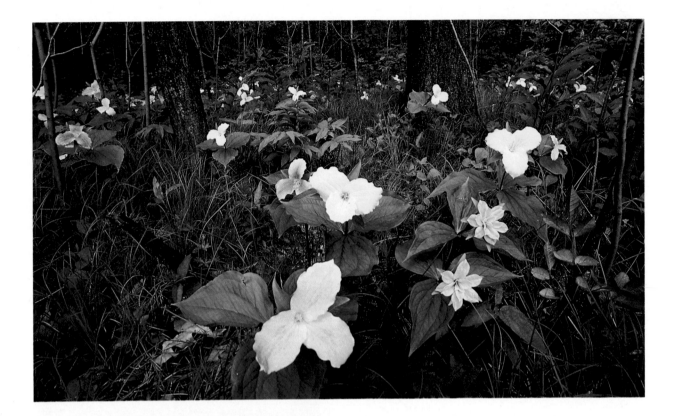

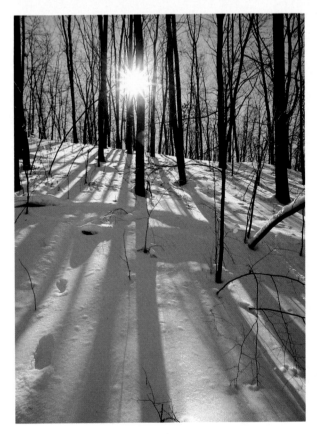

(Above) The strong sense of perspective was obtained by use of a 20 mm lens at f/22. The pleasing arrangement of the trilliums in the foreground compensates for the lack of a center of interest. The full impact of this picture is best appreciated in a 16 × 20 color print.

(Left) Snow pictures are more easily made on a sunny day. Here the sun is the center of interest, but the theme is the shadow patterns on the snow.

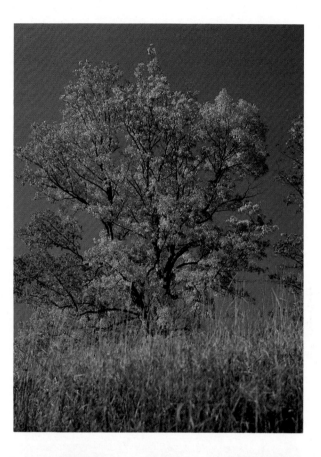

(Right) Photographing autumn colors with black-and-white film is, for obvious reasons, unsatisfactory.

(Below) The speck of green, surrounded by petals radiating outward, is the center of interest in this picture.

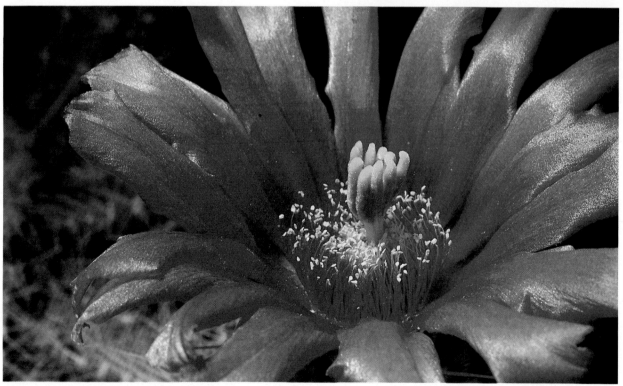

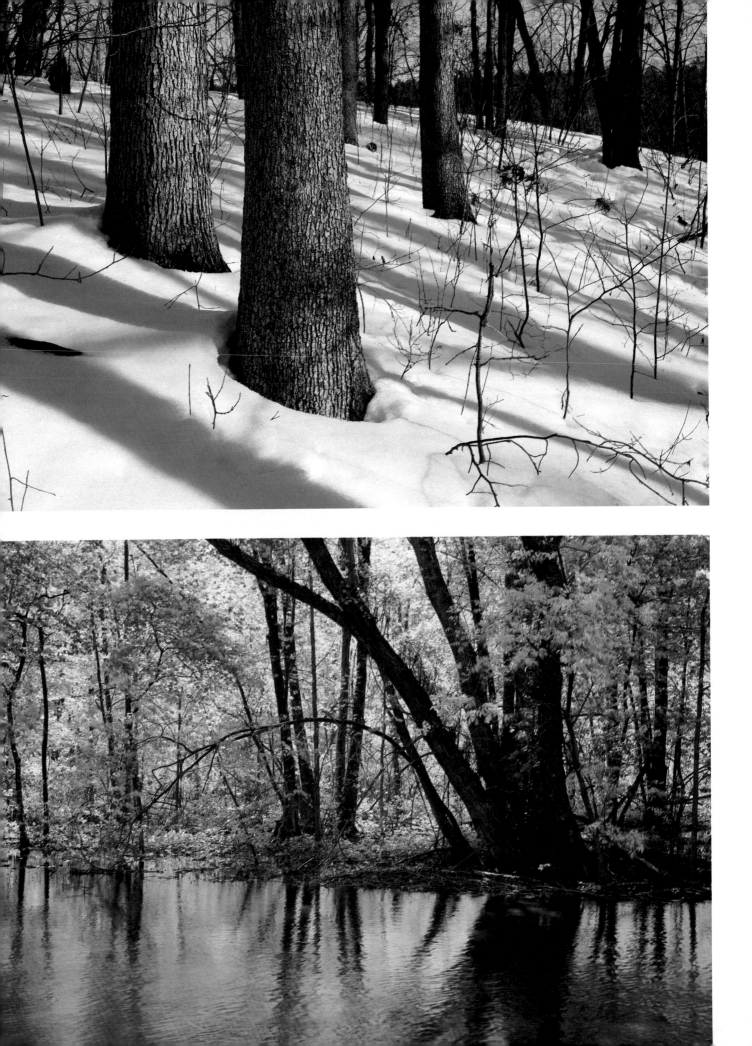

◄ *Without the strong shadows and their diagonal placement, this winter woodland scene would have lacked impact.*

(Facing page, bottom) There is no single strong element in this view of a floodplain, but the total result is most pleasing. Points to consider are: The river is at the ⅓ part of the frame; the base of the tree on the right is at the ⅓ position of the frame; the tree is branching out; and the color is a brilliant, transparent green.

(Below) The sun is gone, but the clouds and reflections make this a pleasing sunset. The last rays of the sun, the lightest area in the photo, are at the ⅓ position.

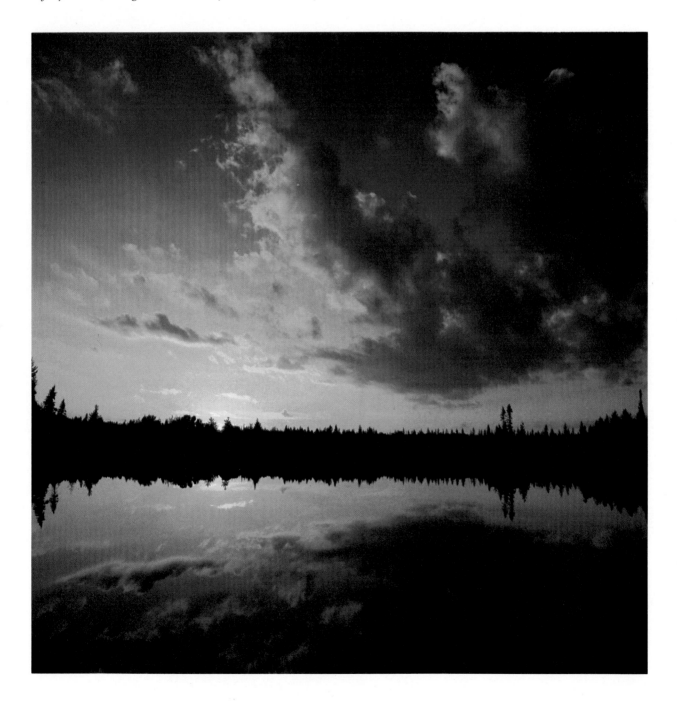

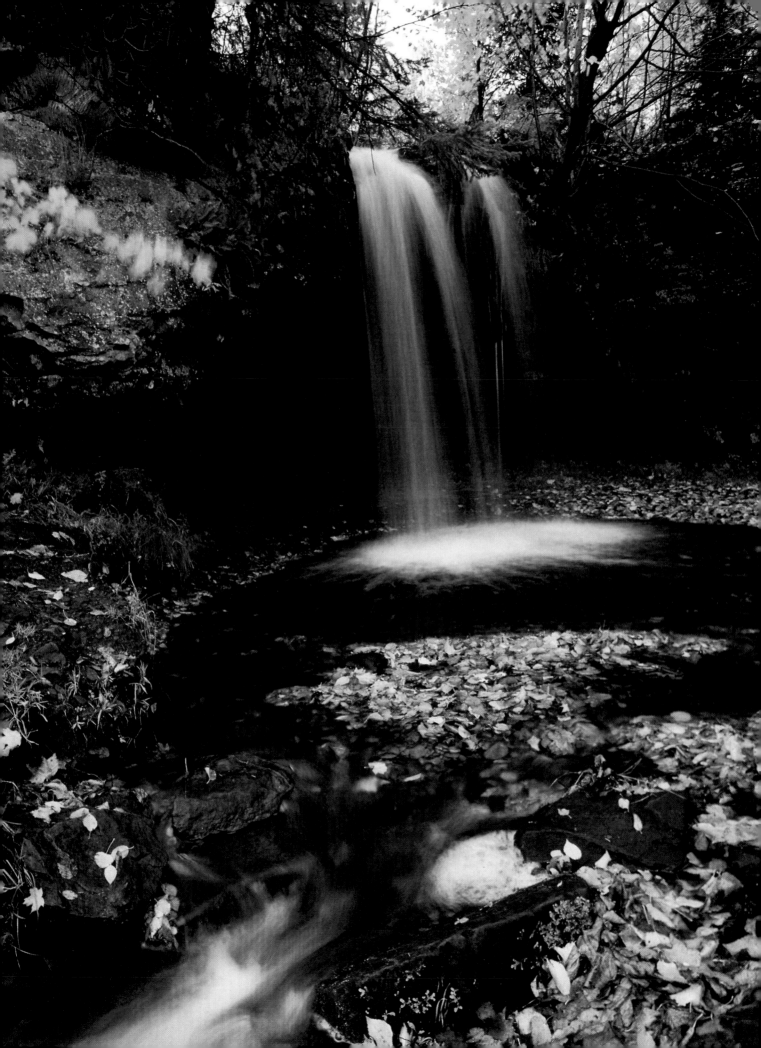

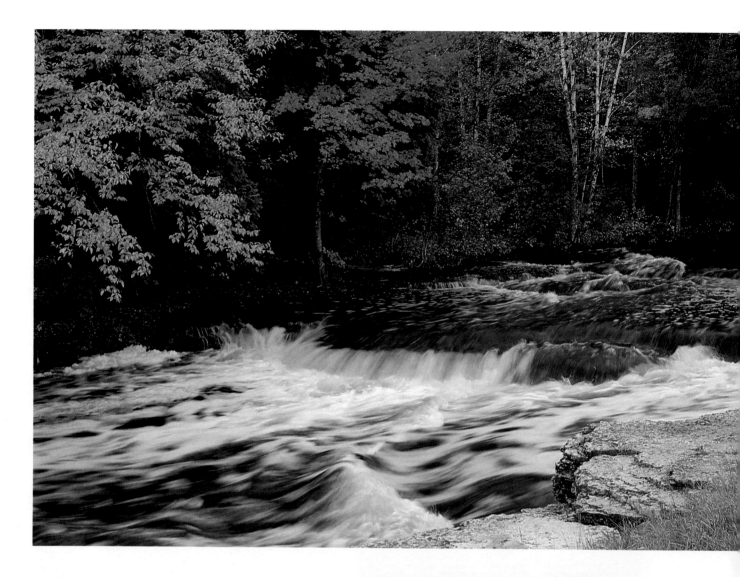

(Above) The fluid appearance of the water results from the use of a 1-sec. shutter speed.

(Right) This picture of Tahquamenon Falls is somewhat abstract and gives the viewer no idea as to height or width. In fact, it is the largest waterfall in Michigan.

◀ A light rain did not reduce the scenic value of this waterfall. To insure a sharp overall picture, f/22 was used with a 5-sec. shutter speed.

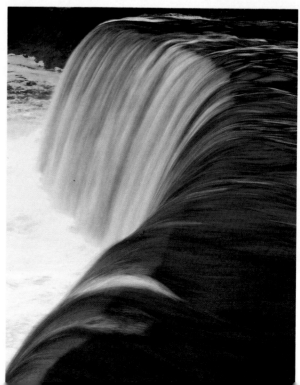

Filters

Two types of filters are sometimes needed in color nature photography: the polarizing filter and the 81A filter.

The polarizing filter can have two very desirable effects. One is to darken a blue sky and increase the color saturation of the scene. The maximum effect is achieved when the camera axis is at 90 degrees (a right angle) to the sun. Since some light is being removed to make the polarizer work, two stops extra light are needed for proper exposure. On a completely clear and sunny day, the polarizer may not be needed because the sky is already very blue. The polarizer would then create an exaggeratedly deep blue sky that is very unnatural.

The second effect, reduction of reflections from foliage, water, or rocks, is maximized when the camera is 34 degrees from the plane of the reflection.

The polarizing filter is rotated to achieve the desired reduction of reflection. After a few years of use in the sun, the plastic in a polarizing filter deteriorates causing uneven darkening and loss of sharpness. It is a gradual process so that no problem may be apparent until use of the filter results in a noticeably unsharp photograph.

The second type of filter is the 81A, which is a light-rose-colored filter used to combat "blue disease," the phenomenon that causes a blue cast to appear in photographs of landscapes with green trees and blue sky. The 81A "warms" the scene and results in a more natural color balance. A UV filter is just not enough to reduce the blueness of a blue-sky landscape. Open shade on a sunny day has a bluish cast which can be removed with an 81A filter. This filter does not require any change in exposure.

Polarizing filter

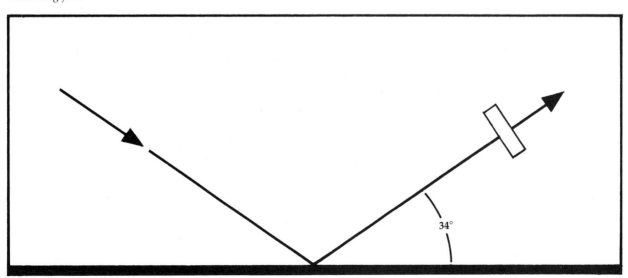

34°

No Polarization

Some Polarization

Maximum Polarization

Use of a polarizing filter has removed reflections from the water and saturated the fallen autumn leaves. The upper photograph shows no effect, the middle one shows some, and the lower one shows the maximum.

The intensity of these clouds was made possible only by using a polarizing filter.

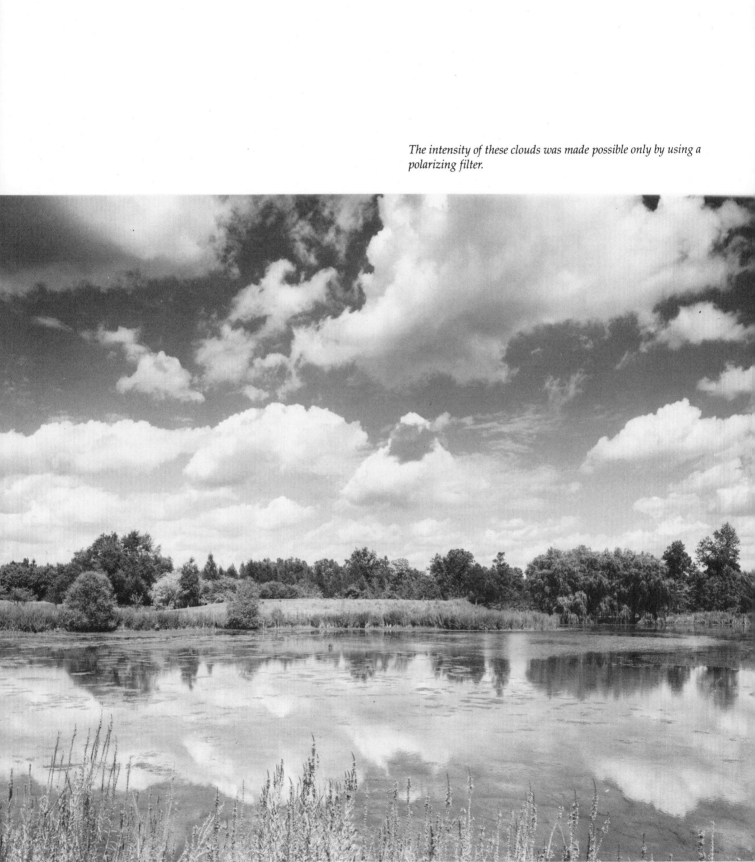

Lens Shade

A lens shade is used to protect the lens from extraneous light that might cause flare. Most long-focus lenses have built-in lens shades that are very functional. The front element of a 55 mm macro lens is so deeply recessed that a lens shade is unnecessary. The difficulty arises with wide-angle lenses where the available lens shades extend only slightly so as not to cut off the frame corners, thus doing little to reduce flare. An alternative to using a lens shade with a wide-angle lens is to use a card, hat, or even hand to cast a shadow on the lens. Be sure to check the viewfinder so that no part of this makeshift lens shade appears in the frame.

Tripod

A tripod is a very necessary tool of the nature photographer because it makes long exposures possible. It also allows for extended study of a subject in order to achieve the best possible composition.

Tripods should have these desirable features:

- Enough steadiness to support the weight of your camera and heaviest lens.
- Legs that adjust quickly by a lever rather than by a cumbersome collar locking ring.
- A screw at the bottom of the center post so that a ball-head can be attached, thus allowing the camera to be used close to the ground.
- A tripod head that can tilt 90 de-grees, allowing the camera to change from a horizontal to vertical format.

With the camera on the tripod, the exposure is made using a 12-inch cable release, the plunger of which is pushed slowly without any jerking motion. An alternative to the cable release is the camera's self-timer.

If caught in a situation where you do not have your tripod, there are often objects at hand that can be substituted for support: for example, a tree, a fence, or your knee. When the camera is hand-held, the number designation of the slowest shutter speed that can safely be used is the same as that of the lens focal length. For example, using a 50 mm lens, 1/60 sec. would be the slowest shutter speed normally used for acceptable results.

Light Meter

A hand-held selenium-cell light meter is still the cheapest and most reliable meter available. There are no batteries to fail at the wrong time. Both reflected- and incident-light meters will handle most any lighting situation.

Shoulder Bag/Belt Pouch

Carrying all of your photographic equipment on long walks can be tiresome. A canvas shoulder bag is a versatile carrying device; it can hold a multitude of items. A belt pouch can be used for small items such as light meter, filters, film, mosquito repellent, etc.

Film

Choice of film is a personal matter. Kodachrome 25 produces the highest image definition of any color film available; when additional speed is needed, Kodachrome 64 is nearly as good. It is possible to make, from a Kodachrome slide, a 16″ × 20″ color print that has almost as much detail as one made from a large 4″ × 5″ color transparency taken with a view camera.

Equipment Checklist

Basic Equipment
SLR Camera
55 mm macro lens
90 mm macro lens
28 mm wide-angle lens
light meter
tripod
cable release
electronic flash
shoulder bag

Handy to Have
20 mm extreme wide-angle lens
24–48 mm zoom lens
100–300 mm zoom lens
35–100 mm zoom lens
additional electronic flash unit
belt pouch
polarizing filter
81A filter
waist-level viewer
spare sync cord

Useful Accessories
Umbrella for rain protection and for shading the background in close-ups.
White card for use as a fill-light reflector in close-ups.
Gray card for exposure reference.
Small screwdriver for minor repairs.
Plastic sheet for kneeling in wet area.
Mosquito repellent.
Drinking water on hot day.
Hat for sun protection.

Using Your Photographic Equipment

The way you use your equipment is what counts—not the equipment brand name or price. Most of your normal photographic activity can be accomplished with the barest of equipment. Only in unusual situations is the expense of exotic accessories justified. A great deal of practical information can be obtained from the camera owner's manual.

Using Different-Focal-Length Lenses

Choice of lens focal length is determined by two factors: the capability of the lens to fill the frame with the subject and the suitability of the perspective characteristic for the subject or theme. You may need to try lenses of different focal lengths in order to achieve the desired effect. The frame may be filled but the perspective incorrect.

It is usually difficult to estimate how a scene will appear with a particular lens—you need actually to try the lens and observe the perspective. You should be aware of the special characteristics and technical problems of a lens of a given focal length.

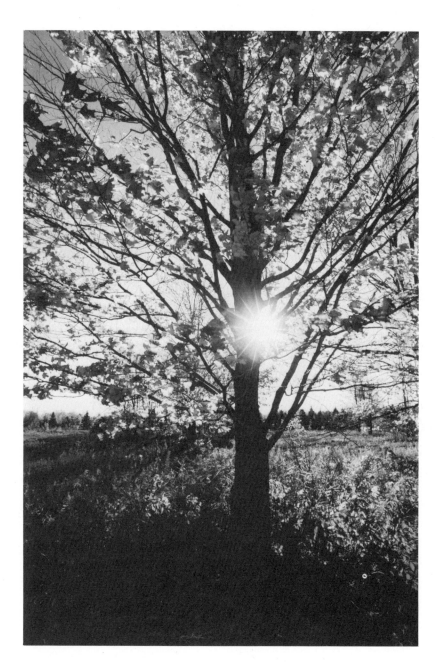

Use of f/22 has resulted in a natural-appearing sunburst.

20 mm Extreme Wide-Angle Lens

A lens of this focal length is difficult to use initially because of its extreme perspective as compared to that of a normal-focal-length lens. The extreme wide-angle lens is justified when:

- The scene is large and you are unable to step back for more subject-to-camera distance.
- You want to emphasize depth-of-field so that everything appears sharp.
- You want to maximize converging lines.
- You want to minimize background and maximize foreground.

28 mm and 35 mm Wide-Angle Lenses

Each of these lenses is a compromise between the 20 mm extreme wide-angle lens and the normal 50 mm or 55 mm lens.

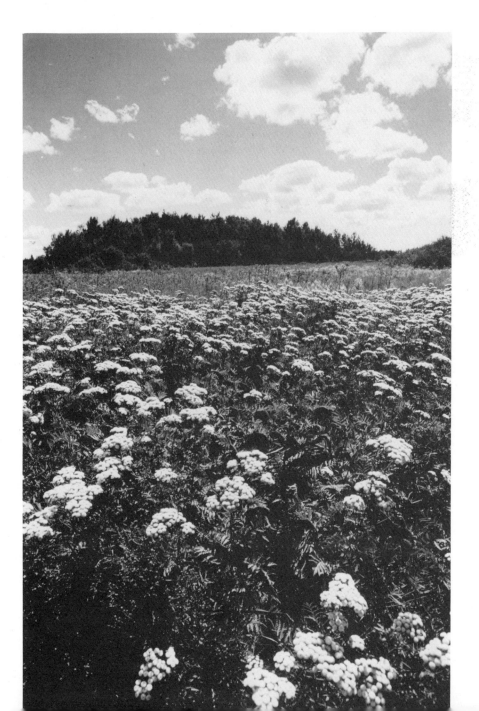

A wide angle lens gives a feeling of circumference.

50 mm or 55 mm Normal Lens

This is the lens with which nearly everyone is familiar. If you could take just one lens on a trip, a 55 mm macro lens would be a good choice because it can be used for both landscapes and close-ups. However, when the 55 mm macro lens is used in the life-size range, there is very little distance from the subject to the lens edge; this can present a lighting problem.

Shown here is a habitat photograph of the large white trillium.

Landscapes are commonly photographed using a normal-focal-length lens.

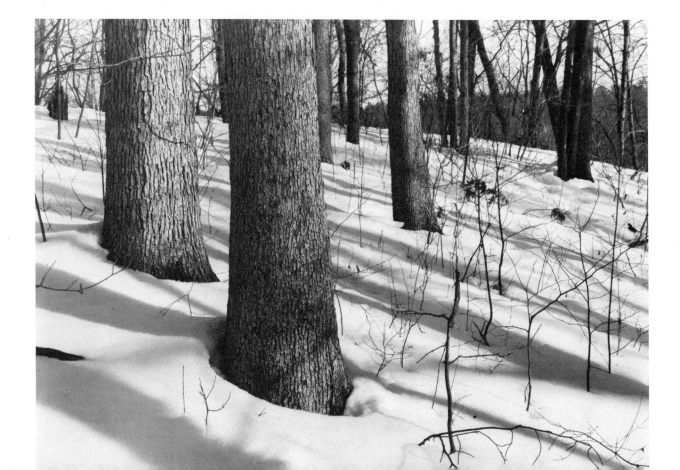

90 mm or 100 mm Macro Lens

A 90 mm or 100 mm macro lens is best-suited for close-up work because it is used farther away from the subject as compared to a 50 mm lens. This is advantageous since small animals are less likely to be disturbed by the photographer. Also, perspective is more natural and there is less chance of casting shadows on the subject.

A lens that should be high on your shopping list is a Vivitar *f*/2.8 90 mm macro. This remarkable lens allows you to focus from infinity to life-size. Other macro lenses require an extension tube or close-up ring to achieve life-size images; such additional equipment is awkward to use when trying to fill the frame with subject matter.

A 90 mm macro lens reduces the chances that your presence will frighten an animal.

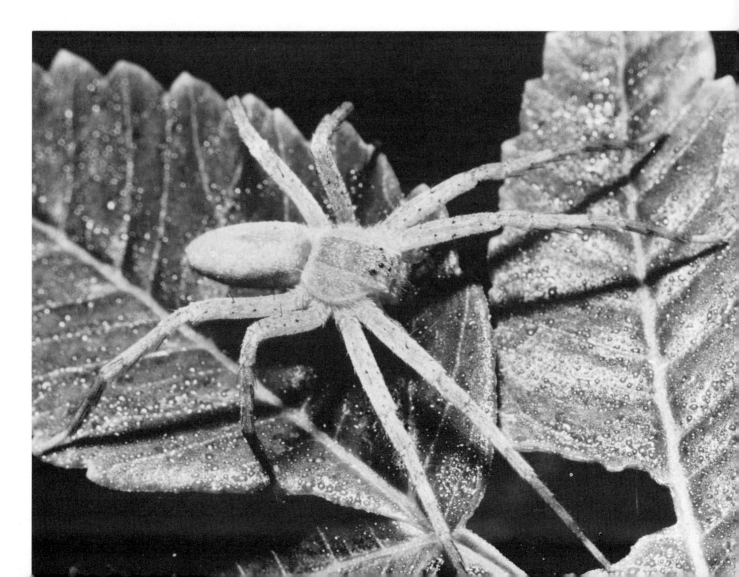

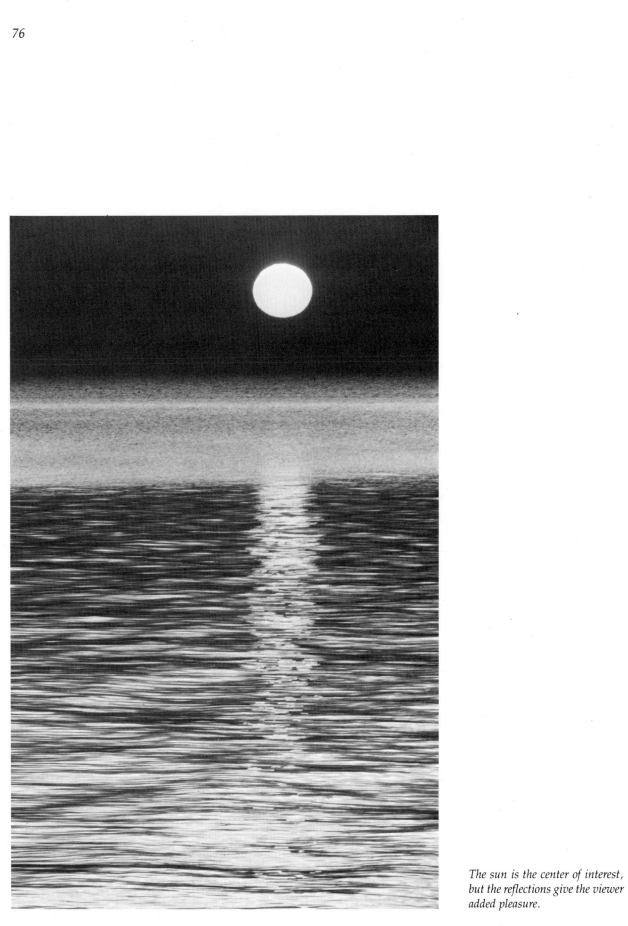

The sun is the center of interest, but the reflections give the viewer added pleasure.

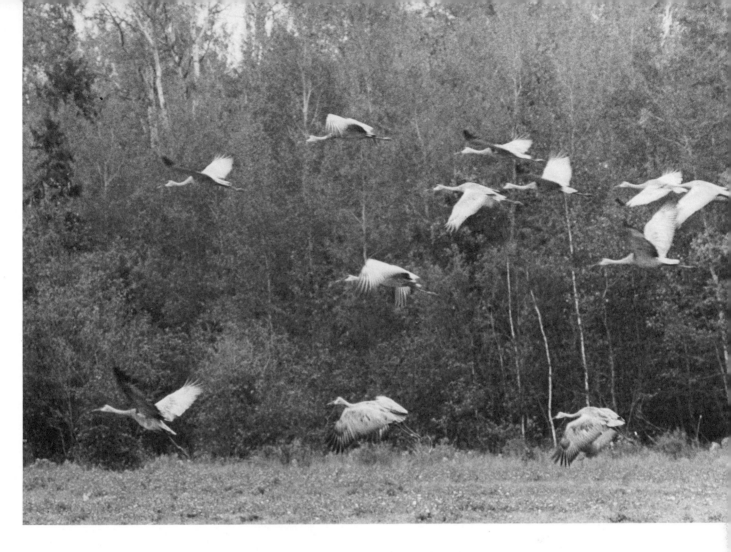

A long lens captures a flock of sandhill cranes contrasted nicely against the dark foliage behind them.

Over 100 mm Telephoto Lens

Because of vibrations, potential for focusing errors, and atmospheric distortion, the telephoto lens presents the greatest technical challenge to the photographer. Vibrations pose an ever present problem that requires a sturdy tripod with its center post down so as to prevent any sway. Just before the exposure is made, lightly touch the lens and tripod to absorb any residual vibrations.

Use of a microprism focusing screen designed for long-focus lenses can make the difference between a sharp photograph and a fuzzy one.

When used at great distances, the 400 mm lens is affected by variations of the atmosphere such as haze, fog, and heat currents. These all cause loss of image quality; under such conditions little can be done except trying another day. On the other hand, it may be possible to make these problems work in your favor to create unusual images.

Zoom Lenses

The advantage of a zoom lens is that it enables you to frame the subject or theme using one lens, without changing camera position. A lens with the zoom range of 35 mm–100 mm can do the work of three popular focal lengths, 35 mm, 50 mm, and 100 mm, and should be considered if only one lens can be taken on a long trip. However, there are disadvantages: Zoom lenses are heavy, have relatively small apertures, are expensive, and require an extension tube to achieve a life-size image. Only your own applications and interests can resolve this equipment predicament.

Depth-of-Field

To the human eye, everything in a scene appears equally sharp at the same time. This does not happen in the photographic process because there is only one point on which the lens can focus. Depth-of-field is the area of acceptable sharpness, from foreground to background, in the scene.

To maximize depth-of-field and approach the effect that the eye perceives, the following suggestions are offered:

- Keep the subject parallel to the film plane.
- Decide what point in the photo is most important (subject or center of interest) and focus on that part.
- If a great depth-of-field is needed, focus on a point about ⅓ from the foreground or about ⅔ from the background. You may also refer to the depth-of-field scale on the lens barrel.
- When extreme depth-of-field is required, use a wide-angle lens. For example, with a 20 mm lens set at 3 feet and $f/16$, the depth-of-field extends from 1½ feet to infinity.
- Use a small lens opening such as $f/16$ or $f/22$. The depth-of-field is the same regardless of the lens focal length when the f-number and the image size on the film are the same.

This skipper butterfly (with a one-inch wing span) is nearly perpendicular to the camera so that every part of the wing is sharp.

Use of f/16 with a 28 mm-focal-length lens permitted everything in the photograph to appear sharp.

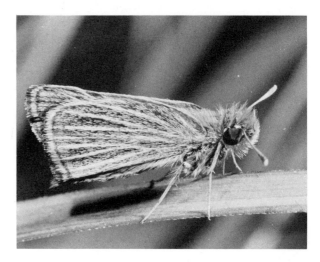

Obtaining Sharpness

Producing a slide with the sharpest obtainable image requires a combination of techniques.

- Accuracy is important when focusing—select a part of the subject that provides a sharp, bright point, such as a hair, twig, leaf, or other small detail.
- Use a microprism focusing screen.
- For hand-held shots use a shutter speed equal to the lens focal length—a 100 mm lens would require 1/100 sec. or 1/125 sec.
- Use an intermediate aperture—if the lens is marked from $f/2$ to $f/16$, the intermediate aperture would be $f/5.6$.
- Keep the front and rear lens surfaces free of dust, dirt, and fingerprints.
- Use Kodachrome, which has the highest image definition of any color slide film available.
- Lock up the mirror before the exposure.
- Use a sturdy tripod to eliminate camera movement.

Just about everything went wrong with this picture situation, in which a 400 mm lens and 2× extender were used. The wind caused the tree to move at the wrong time, and this very unsatisfactory photograph resulted.

A combination of subject movement caused by the wind and camera shake resulted in a very fuzzy photograph.

Exposure Considerations

The shutter speed chosen should be a compromise between the depth-of-field required and the shutter speed needed to stop subject motion. Suppose your subject is a bird in flight on a sunny day. With Kodachrome 25, a shutter speed of 1/250 sec. at an aperture of f/5.6 should stop the motion but give a narrow depth-of-field. If the subject is stationary, such as a landscape, and an extreme depth-of-field is needed, the exposure would be something like 1/15 sec. at f/22.

Thus, you actually have a number of possible aperture/shutter-speed combinations and resulting effects.

EFFECTS OF APERTURE AND SHUTTER-SPEED VARIATION
(for Kodachrome 25 on a sunny day)

Lens aperture	f/4	f/5.6	f/8	f/11	f/16	f/22
Shutter speed (in seconds)	1/500	1/250	1/125	1/60	1/30	1/15
Lens aperture opening	Large .Small					
Depth-of-field	Least .Most					
Shutter speed	Fast .Slow					
Motion-stopping ability	Most .Least					

If the subject is bright, as, for example, a white flower, you should underexpose by ½ or 1 f-stop. If the subject is dark, you should overexpose ½ or 1 f-stop to lighten the subject. To assure a perfect exposure, you must bracket. This means making three different exposures of a particular scene: one at the estimated reading, one at ½ f-stop below that reading, and one at ½ f-stop above it. When presented with a once-in-a-lifetime situation and an unsure exposure reading, be sure to bracket. Taking a meter reading from a gray card (which is a color standard) can often resolve such exposure problem.

There are three factors that can upset your meter reading: use of filters, lens extension, and film reciprocity failure. Filter compensation is determined by checking the filter's directions for such correction and adding the appropriate amount of light. Compensating for lens extension, which occurs when the lens is used for close-ups, also involves adding light (for example, when the image is life size, add two extra stops of light).

Film reciprocity failure occurs when the shutter speed is ½ sec. or longer. Long exposures on Kodachrome 25, unlike those made on Ektachrome, do not seem to require heavy color-corrective filtration to correct color shifts. Use the accompanying chart as a guide when making long exposures.

COMPENSATION GUIDE FOR RECIPROCITY FAILURE

If shutter speed in seconds is:	1/2	1	2	4	8
Then use this corrected speed:	1	2	4	8	16

Determining Exposure

Determining exposure is a step-by-step process. Consider making a life-size close-up under these circumstances: lighting conditions are those of a bright hazy day, extreme depth-of-field is required, a polarizing filter is used, the film is Kodachrome 25, and a hand-held meter indicates an exposure of 1/30 sec. at $f/11$. The steps are given in the accompanying chart.

VARYING EXPOSURE FACTORS IN GIVEN SITUATION

Variable	Compensation Needed (in f stops)	New Lens Aperture	New Shutter Speed
Polarizing filter	2	$f/5.6$	1/30 sec.
Lens extension	2	$f/2.8$	1/30 sec.
Extreme depth-of-field	—	$f/22$	2 sec.
Film reciprocity	—	$f/22$	4 sec.

To bracket in this situation you would not change the lens aperture but instead change the shutter speed; the exposure would be $f/22$ at 3, 4, and 6 seconds.

Some in-camera exposure meters can take into account filter effects and lens extension, thus leaving only film reciprocity failure to consider.

Background Controls

Backgrounds are often cluttered, bright, and distracting, and thus can divert the viewer's attention from the subject or theme of a photograph. The following techniques can be used to emphasize the subject and subdue the background:

- Use of a wide-angle lens can make the background objects smaller and less noticeable. Conversely, a long-focus lens can make the background objects larger, thereby reducing the area covered.
- The background should be of lighter or darker intensity than the subject, or of a different color, to achieve contrast.
- Changing the camera viewpoint can affect the intensity or color of the background. A low viewpoint might utilize a blue sky while a high viewpoint might use the dark ground. Use whichever provides the better contrast for the subject.
- Selective focus can help isolate the subject by completely blurring the background. It is achieved by focusing on the subject and using a large aperture such as $f/2.8$ or $f/4$.
- Light falling on the background can be controlled in close-ups by using an umbrella or similar device to shade the background, thus making it darker.
- The "hand of man" or other small background distractions can often be eliminated by adding naturally occurring objects such as small branches.
- Artificial backgrounds such as green or blue poster board are used by some photographers to eliminate distracting backgrounds in close-ups. However, such contrivances often yield strange and unnatural results and therefore should be used only as a last resort.
- Sometimes the background can be cleaned up by removing stray twigs, branches, leaves, rocks, etc. However, do not go to an extreme by removing everything from around the subject, thereby giving an unnaturally tidy appearance.
- Specific background problems can often be isolated by focusing the lens on the background to determine what the distractions are and then taking corrective steps to eliminate those distractions.

Isolating Problems

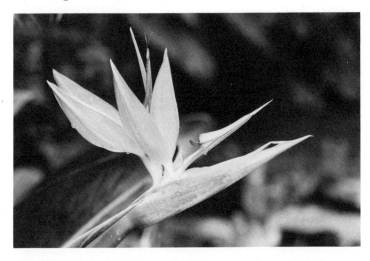

Focusing on the subject at f/2 or f/2.8 does not reveal any background problems. This photograph, taken at f/2.8 shows how the scene looked in the viewfinder—no background problems were evident. This also is an example of selective focus where the lens is focused only on the subject and where a large diaphragm opening is used.

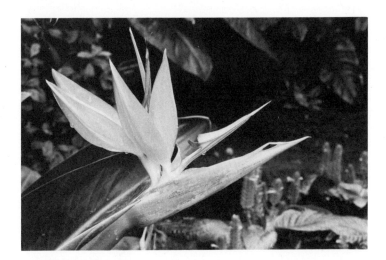

Nature subjects are rarely on one plane parallel to the camera as is this bird of paradise flower. Often f/16 is needed to maintain overall subject sharpness. An exposure at f/16 reveals problems such as the sign at the left third position.

After a suitable position for the camera has been located, the lens is focused on the background to identify and isolate any problems. The sign is now clearly evident in addition to another at the right.

Artificial Backgrounds

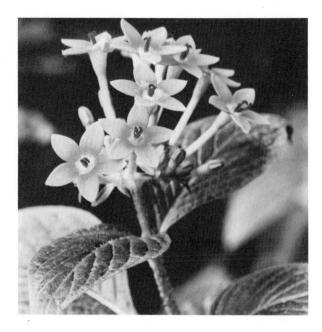

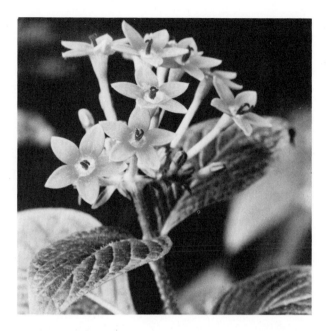

Natural light. *Note the lack of shadows, which is a characteristic of diffused lighting. There is also a lack of contrast throughout the photograph.*

Electronic flash. *Shadows are now evident on the subject. The background is definitely black since the light reaching it was too weak for the proper exposure.*

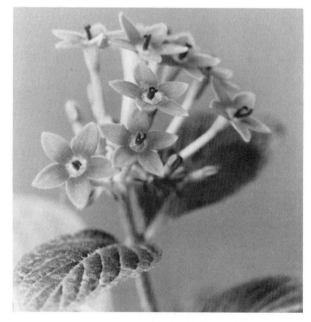

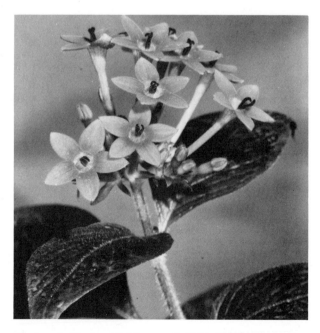

Natural light and blue card. *A light-blue card placed behind the subject can appear as sky. However, it also may appear artificial and should be used only as a last resort. Avoid a bird's-eye view when using a blue card since the ground is not blue.*

Electronic flash and blue card. *This combination is often unpredictable because shadows may form on the card; it definitely reveals the "hand of man."*

Background Distraction

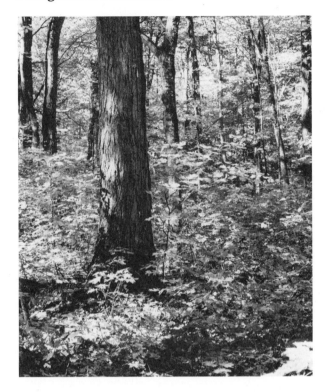

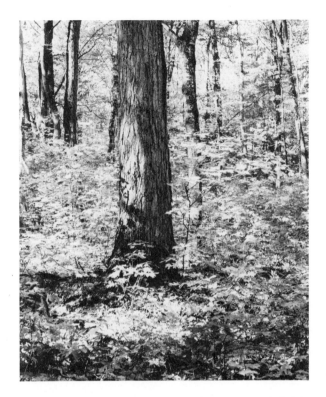

The large white area at the lower right is a distraction. The eye is always drawn to the brightest point of the picture, which, here, draws the eye away from the photograph.

When the problem was realized, the camera was moved slightly to the left, thus eliminating the white area.

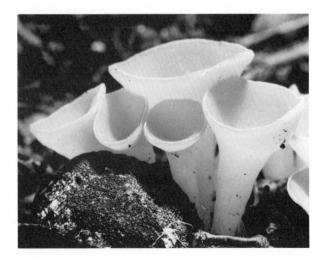

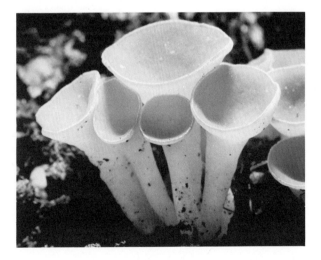

The dark object in front of the mushrooms is a distraction, since it is hiding part of the subject.

The object has now been removed, revealing the base of the mushrooms. When cleaning up an area, be careful not to overdo it and show nature in a unnatural manicured manner.

Viewpoint

A worm's-eye viewpoint is sometimes difficult to obtain because it is not always possible to get close to the ground. Certain equipment makes it possible to photograph from this vantage point. A waist-level viewer will allow you to comfortably focus with the camera on the ground. A tripod that has a ball-head attached to the bottom of the center post will permit use of the camera close to the ground. A table-top tripod with a ball-head will also allow you to work with the camera low to the ground. A worm's-eye viewpoint does not necessarily mean that the camera needs to be on the ground, only that the camera be aimed upward.

A bird's-eye viewpoint involves positioning the camera higher than the subject. This could mean merely photographing a sub-ject located on the ground while standing up. However, a subject often demands greater elevation. A small step ladder can be a handy item to use if the photograph is planned and the ladder need not be carried very far. Alternatives to using a ladder include standing on your car and climbing a tree.

Examples of viewpoint are given in Chapter 6, "Composition—The Second Element of Impact."

Maximum depth-of-field was achieved by using the lens at f/16.

A "bird's-eye" view from the side reveals the characteristic markings of the wood frog.

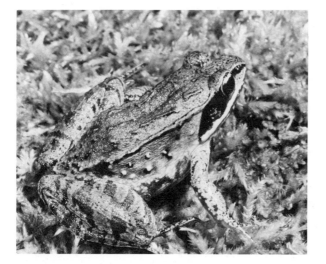

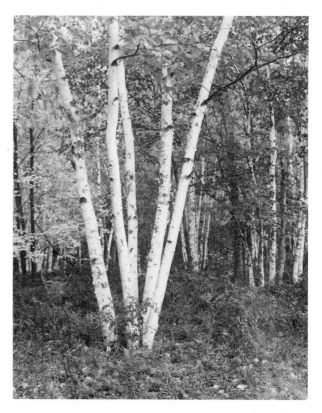

Types of Light

A subject can appear completely different depending on the lighting conditions. Having a command of lighting technique and making the most of it is part of being an artist.

It is important to recognize what type of light is most flattering to a subject or theme and to have the light where needed. There are five basic types of light.

Diffused Lighting

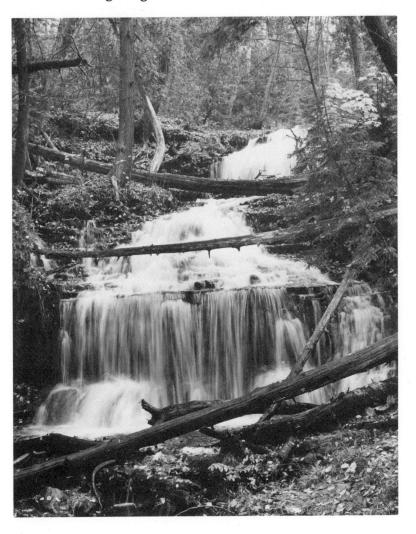

Diffused lighting is characterized by the complete lack of shadows that occurs on an overcast day.

Front Lighting

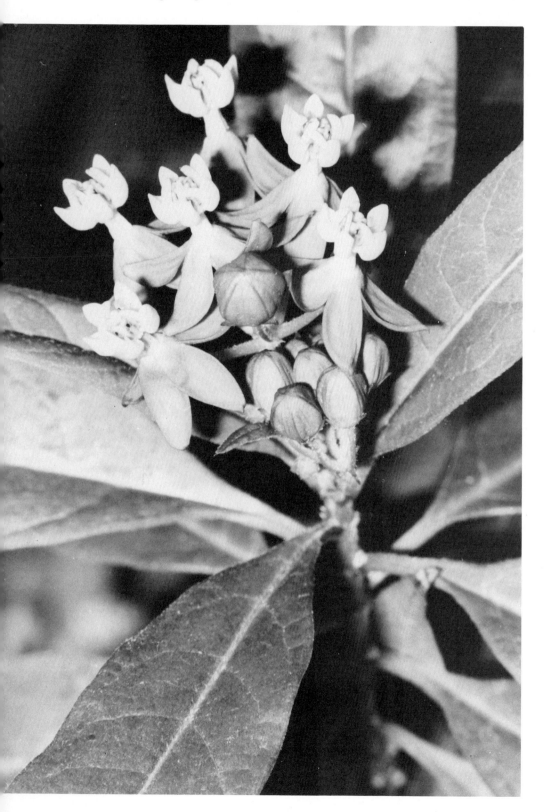

Front lighting involves placing the light source near or along the same axis as the camera, resulting in a harsh, generally shadowless subject. It is not often encountered, except early or late in the day. This type of light is also typical with a flash mounted on a camera.

Side Lighting

Side lighting emphasizes the subject's details and texture with strong shadows.

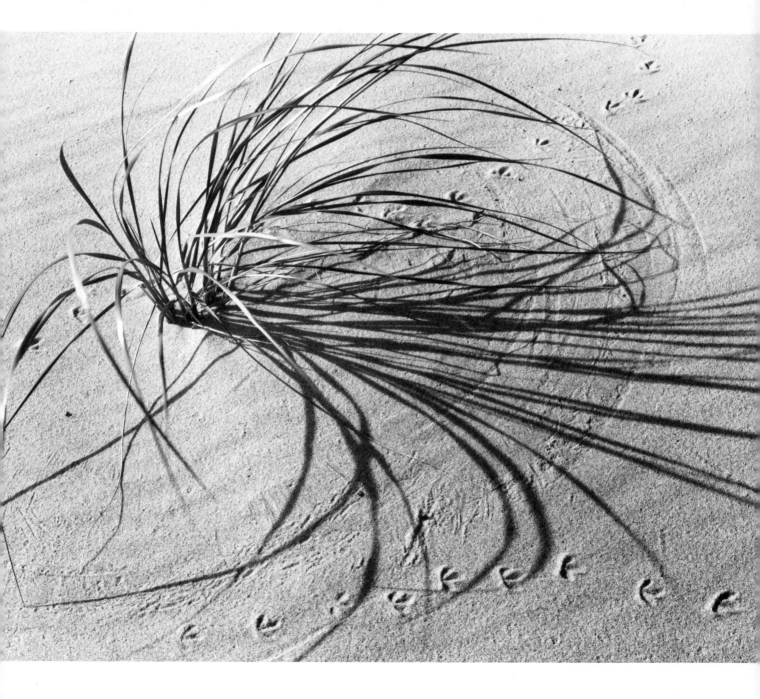

Back Lighting

Back lighting produces dramatic results by highlighting hairs and other details, giving an inner glow to transluscent objects, and isolating the subject from the background.

Lighting at 45-Degree Angle

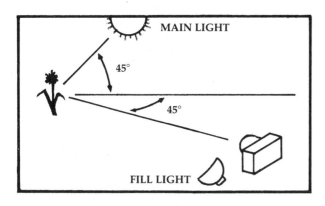

Forty-five-degree lighting.

Forty-five-degree lighting is common. It is created by placing the light source about 45 degrees to the right or left of the subject and about 45 degrees above the subject.

Fill Light

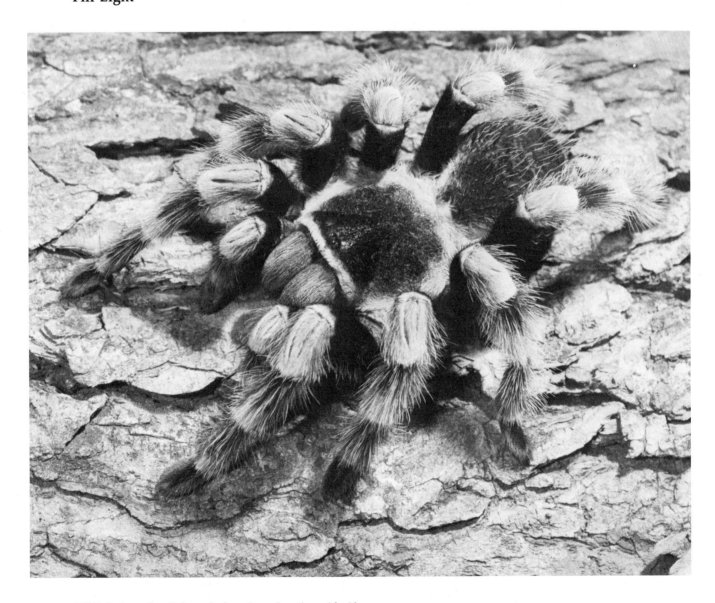

Fill light is used to lighten shadows in conjunction with side, back or 45-degree lighting. The source light is usually placed near the camera and to the side of the subject opposite the main light.

Artificial Light from Ground

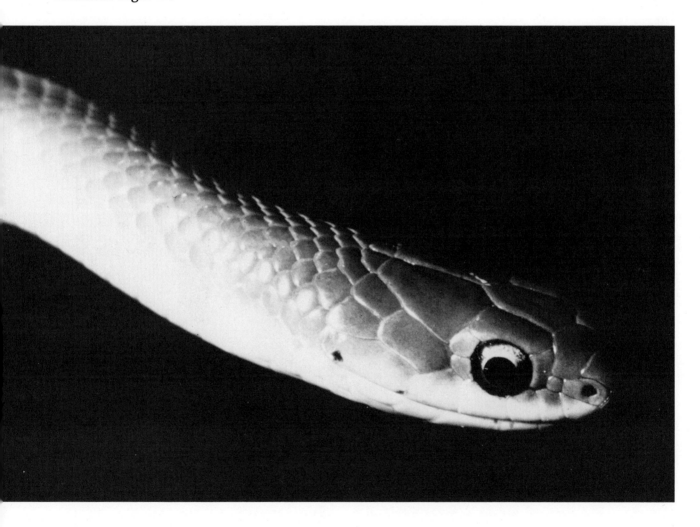

Although light from the ground may sometimes be pictorial, it is not natural and thus shows the "hand of man."

Available Daylight

Available light must be studied for direction and modeling characteristics whether conditions are those of a sunny, hazy, or cloudy day. If the light does not suit your plan, come back at a later time when it is more favorable.

The late afternoon sun lighted the river but created excessive shadow area.

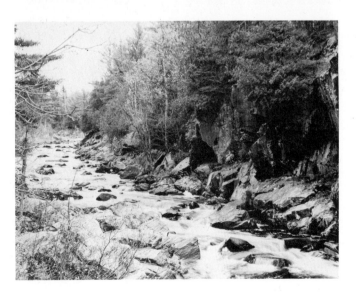

The next morning diffused light illuminated the rock faces, giving a greater record of the area.

Electronic Flash

Electronic flash can be used to simulate the qualities of the sun in close-ups. The flash unit should have a guide number of about 60 for use with Kodachrome 25. The easiest situation for a single flash is at the 45-degree position. The fill light can be from a white card held near the subject, opposite the side from which the flash is directed, to reflect some of the main light into the shadows.

When electronic flash is used, the lighting should appear natural. Flash units should not be arranged so that the main light source appears to be coming from the ground; such a lighting condition does not occur in nature and would be obviously artificial. Using three flash units can result in unnatural criss-cross shadows; it is better to use just two flash units, one for main light and one for fill light.

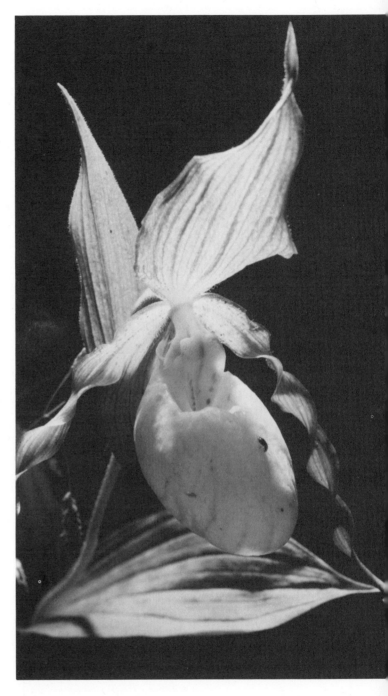

The main flash is directly behind and up from the flower with the fill flash near the camera.

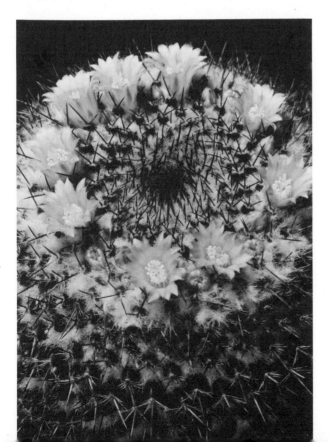

The main flash is above and behind the cactus with a fill flash near the camera.

Fill Flash

It is possible to use a second flash as a fill light instead of a white card. The fill flash should then have a guide number of about 30 for use with Kodachrome 25 and should be held near the camera, opposite the side from which the main light is directed. The fill flash is connected to the camera and the main flash equipped with a "slave unit" to trigger the main flash at the same time as the fill light.

Two flash units having the same guide number may also be used. The fill flash would then be positioned about 1½ times as far from the subject as is the main flash.

A single flash unit (with a guide number of 60 with Kodachrome 25) can be used to provide fill light that supplements existing light in close-ups or habitat situations. Suppose the camera is 5 feet from the subject and the exposure reading with Kodachrome 25 is $f/16$ at 1/30 sec. on a sunny day. The fill flash should be 1 or 1½ f-stops less light than the main existing light. Now, by looking at the calculator dial of the flash unit, figure out how far from the subject the flash must be positioned at a setting of $f/11$. The answer is 5 feet. Therefore, the exposure will be $f/16$ at 1/30 sec. with the fill flash held just over 5 feet from the subject.

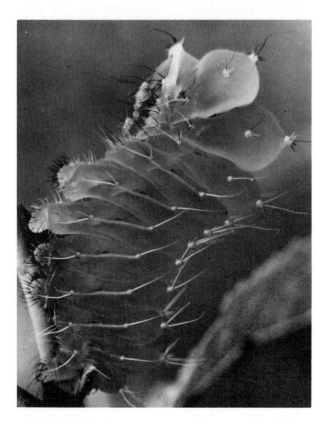 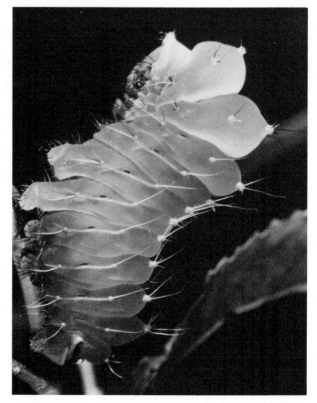

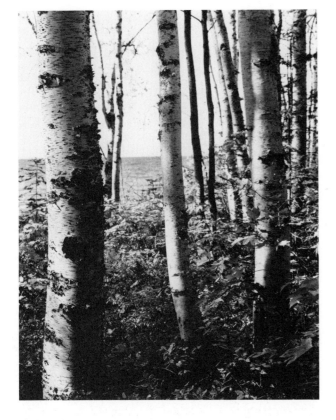 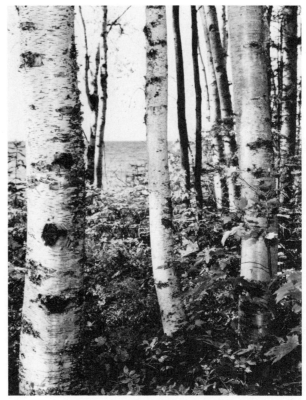

Here, the shadow areas are too dense.

Use of one flash resulted in shadow penetration. The exposure was set so that the flash underexposed by 2 f-stops as compared to the natural-light exposure. This is an extreme example of fill light; the trees may have appeared more natural with 2-1/2 or 3 f-stops underexposure of the flash.

◀ *The green color of the moth larva (far left) is similar to the background. Use of the flash as the main light, and the natural light as fill (left), resulted in a dark background that isolated the subject.*

Poor Weather Conditions

Bad weather often lessens the motivation to venture out of doors in search of suitable nature subjects. This is ironic; poor weather itself can enhance the impact of nature photographs because it causes subjects to take on a new appearance. The discomfort you experience during such outings will hopefully be offset by the satisfaction of obtaining new and different photographs.

During the winter it is usually too difficult to keep your camera warm by carrying it in your pocket or under your jacket and making only a few quick exposures. When doing serious work, allow the camera to become cold and carry on as usual. Thin leather gloves will allow you the dexterity needed to make adjustments. Be careful not to let snow melt on a warm camera since the water will eventually freeze. Do not breathe on a cold lens to remove foreign matter; your breath will condense on the lens surface causing real trouble. When bringing camera equipment out of freezing weather, first place it in a plastic bag, which will allow the condensation to form on the bag and not the equipment.

Any prolonged use of your camera in the rain will require the use of a "camera raincoat." This is just a clear plastic bag over the camera with a hole cut for the lens and held in place around a lens shade with tape or a rub-ber band. A skylight filter or an 81A filter will keep raindrops away from the lens surface. Just before making the exposure, remove any water drops from the filter with a dry, soft towel, which can be kept in your pocket. Ready-made raincoats are available from Spiratone of New York.

Wind is a frequent and difficult obstacle to overcome. Use of a high shutter speed may not always be possible because of a low light level or extreme depth-of-field requirements. Often the wind is most calm early or late in the day. Try waiting for a calm moment between gusts.

Electronic flash used for close-ups will stop motion, but be careful that the wind does not blow the subject out of focus during the actual exposure. For especially difficult conditions, a small windbreaker constructed out of clear plastic can hold back the wind.

Dusty areas or sand dunes are extremely hazardous on windy days since small particles can become trapped in the lens mechanism, exposure meter, or camera body. Changing film is especially dangerous because one particle of grit can cause a scratch in the film that will be long remembered. If a camera is dropped into sand, it may need a major overhaul.

Simplified Close-Up System

This basic close-up system is presented so that a beginner can take good photographs with little technical involvement. The system depends on standardization of equipment so that dependable and repeatable results can be obtained. Included are the following elements:

Camera—SLR
Lens—55 mm macro
Film—Kodachrome 25
Flash—with guide number of about 60 for use with Kodachrome 25
Fill light—white card about 8″ × 10″ with a hole in the middle

To use this equipment, cut a hole in the middle of the white card (white poster board is good) so that it fits over the lens. The lens is set at $f/16$ and the flash held so that the distance from flash to subject is about the same as the distance from the back of the camera to the subject. The flash is positioned either behind the subject, to one side, or overhead. The white card is then tilted to reflect light from the flash into the shadow areas. When the lens focusing scale reads over two feet, you will need to change the aperture to $f/11$–16 or move the flash closer to the subject. The closer the flash is to the subject, the more diffused the light appears. Subjects that are photographed life-size with the flash near the camera will have few shadows.

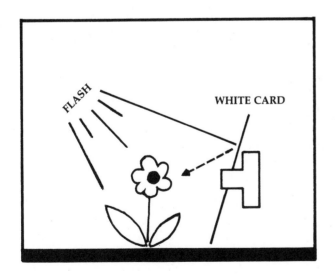

Simplified system for backlighting.

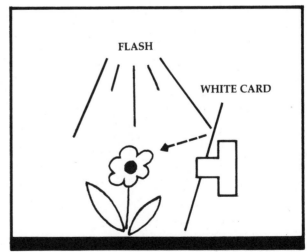

The flash can also be held directly over the subject. When flash is used in this way, the lighting is very diffused because it is so close to the subject.

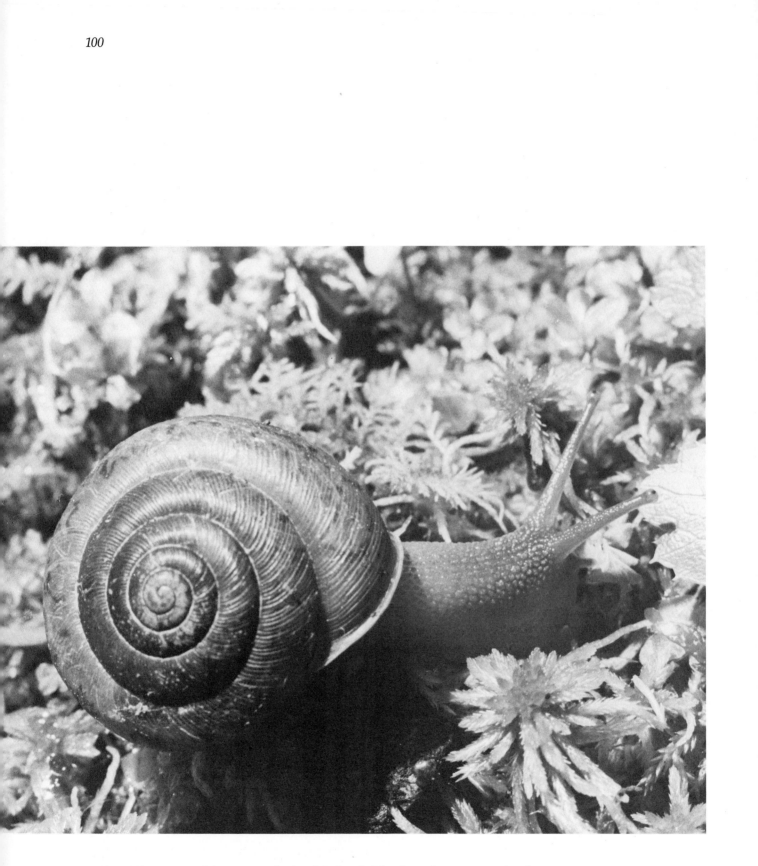

Although the entire snail deserves examination, it is the spiral that draws the eye to one point. Some fill-in flash from the right would have helped to illuminate the head and give it equal impact.

CHAPTER 8

Steps in the Photographic Process

There are different stages of achievement in nature photography. A snapshot can be made by anyone and is often the basis for further effort. The habitat or record photograph is usually taken to show the subject in its natural surroundings. Exhibition photographs, which are typical endeavors of camera-club members, represent the culmination of technical training. Finally, artful nature photography has a balance of content, composition, and technique, all of which result in impact and an emotional presence that causes it to be remembered and to appear fresh and vibrant whenever viewed.

The reluctance of critics to accept photography as art has one latent cause. Most early photographs were snapshots and this situation still prevails. Thus the beginning photographer can justifiably say, "I have made photos just as good" and be right. Even the non-photographer thinks this way.

The difference between the amateur and the professional is that the pro is able to successfully complete an assignment. The difference between the beginning photographer and the photographic artist is that the artist recognizes the potential of a subject or theme and is able to capture the image successfully on film.

The most carefully made plans for a photograph may be successful but the factor of luck cannot be discounted. To be at the right place at the right time can result in photographs that might not be possible to duplicate. It is up to the photographic artist to recognize the opportunities as they are encountered.

List of Steps Involved

The following steps in making a nature photograph are presented as a starting point for the beginner and as a reminder for the advanced photographer. You may wish to jot them down on a 3" × 5" card for handy reference in the field. After following them a few times, you will find that they become automatic.

- Recognize the subject or theme.
- Consider how to present the subject in an effective graphic form.
- Decide if the format is to be horizontal or vertical.
- Isolate the composition. If good composition is not apparent, re-examine the subject from different views and angles; view the scene upside-down to recognize the abstract quality.
- Fill the frame with a single theme.
- While looking through the viewfinder, check each part of the frame for distracting elements in the foreground and background.
- Focus carefully on the most important part of the subject or theme.
- With artificial light, ask yourself if the lighting is suitable for the subject and whether it appears natural.
- Take the exposure reading and decide on the aperture and shutter speed.
- Ask yourself, "Have I maximized the content, composition, and technique?" If so, make the exposure.

These ideas are presented one by one but as you become involved with a subject and theme in a particular situation, you may want to change your original picture concept. In this case, start going over the checklist again. Not all attempts at nature photography will be successful. Each exposure is part of the learning process; early mistakes can lead to future successes. You may wish to record exposure data in a notebook and transfer the information onto each slide to facilitate comparison of various results.

After making photographs and packing up your equipment, take a second look around to be sure that you have not left behind any equipment. Small items such as cable releases, lens caps, and filters can easily be lost. Be sure you have not littered or disrupted the area in which you have photographed. Take only pictures, leave only footsteps.

CHAPTER 9

Potential Nature Subjects and Selected Suggestions

This chapter suggests some commonly photographed nature subjects but by no means contains a complete list. No photographer has all the answers in nature photography; each should experiment by trying different approaches to various subjects. Talent is developed only by continued practice.

POTENTIAL SUBJECTS AND THEMES

Botany:
 Flower, tree, bark, leaf, fern
 Mushroom, fungus, lichen
 Bud, fruit, berry, seed, pod

Scenic:
 Weather—fog, rain, clouds, rainbow, dew, lightning
 Winter—snow, ice, frost
 Autumn color
 Moving water—stream, creek, river, waterfall
 Body of water—lake, pond, shoreline, wave, reflection, swamp
 Sunset, sunrise, moon
 Landscape—forest, dune, desert, prairie, bog, mountain
 Geology—mineral, fossil, cave, rock formation

Landscapes

Ansel Adams called landscape photography "the supreme test of the photographer—and often the supreme disappointment." The objects in a landscape do not really change, you take what you find. The photographer must use variables such as camera position or viewpoint, lens selection, time of day, and weather conditions to successfully record this phenomenon of nature.

Seeing is the first step in the process. Remember that the eye does not see what the camera sees. The eye sweeps from left to right, up and down, but a camera records just one segment of the scene.

In photographing landscapes try adding scale by including an object of generally known size, such as trees or leaves. Avoid meaningless and empty foreground. Move closer or use a telephoto lens to fill the frame. A wide-angle lens is useful for a feeling of spaciousness or for extreme depth-of-field. Lighting is most important; you must see, feel, and watch its effect during the day. The most emotional landscape is one that instills in the viewer the desire to walk into the picture and take a closer look at the center of interest or theme.

Here are examples of landscape photographs.

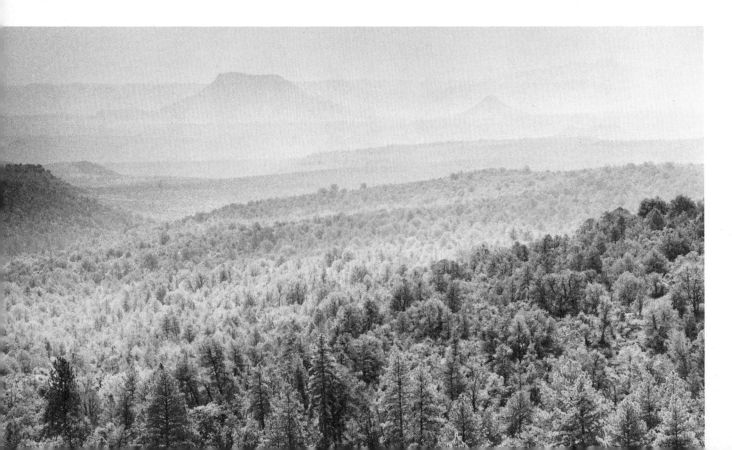

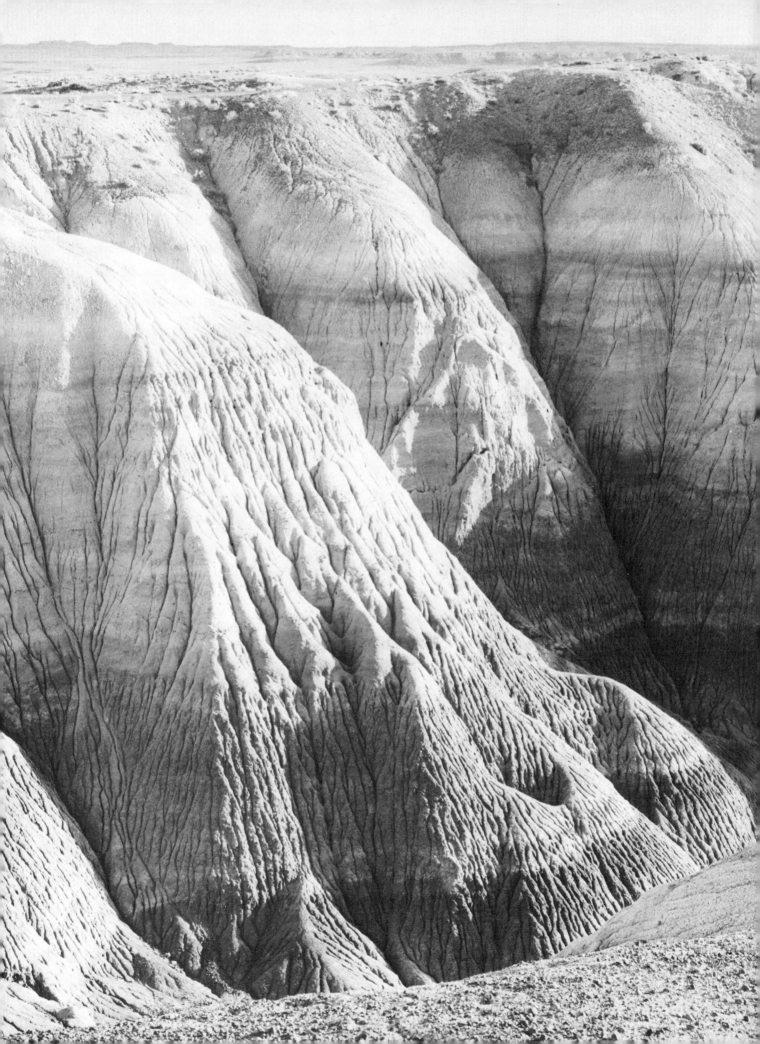

Forest

Trees may be everywhere, but try to select one or a few that seem to be isolated from others. Generally, avoid using a wide-angle lens to capture a forest scene because:

- The perspective is noticeably distorted causing trees in the distance to appear too small proportionately.
- When the camera is tilted to include more trees and less ground, the resulting image shows trees leaning unnaturally.
- A wide-angle lens makes everything appear small when, in reality, trees are almost always large and majestic.

A 90 mm lens and sometimes a 50 mm lens give a truer rendering of a forest. Shooting straight up into the crown of the forest results in still a different viewpoint. Here, a wide-angle lens such as a 28 mm or 20 mm is most advantageous. Forests are best shot on bright, overcast days; on sunny days there are too many hot spots coming through the forest crown. Rainy days are especially interesting because there is a brilliance on everything—a frosting effect.

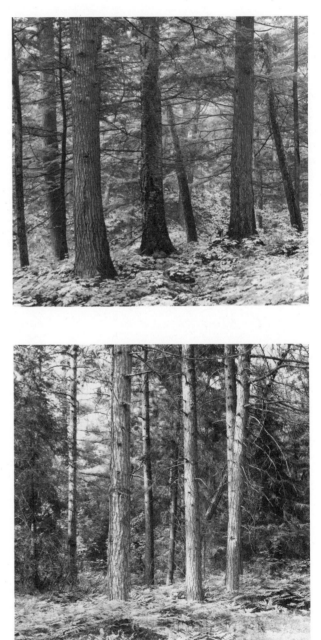

A bright overcast day usually is best for photographing in a forest because of the even light. Exposures, however, can be very long (top). A clearing next to these red pine trees (right) allowed morning sunlight to fall evenly into this scene.

Fog

The fog itself is the picture, with the landscape, trees, and rocks serving only to unify the whole and to act as a means of showing the presence of fog. Exposure is sometimes difficult because most of the scene is diffused. Either an incident light meter, or a gray card and reflected-light meter, may be used. You will need to underexpose the scene; for example, at a reading of 1/30 sec. at f/8 the exposures would be 1/30 sec. at f/8-11, and f/11.

The lone tree on the left gives a feeling of depth to the theme of the photograph—fog.

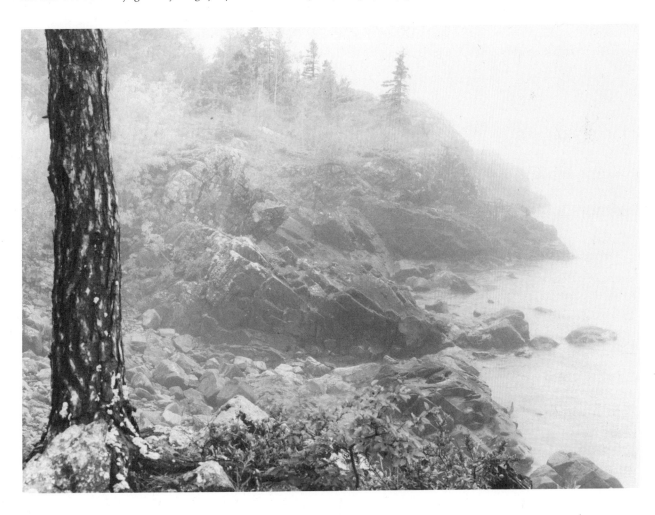

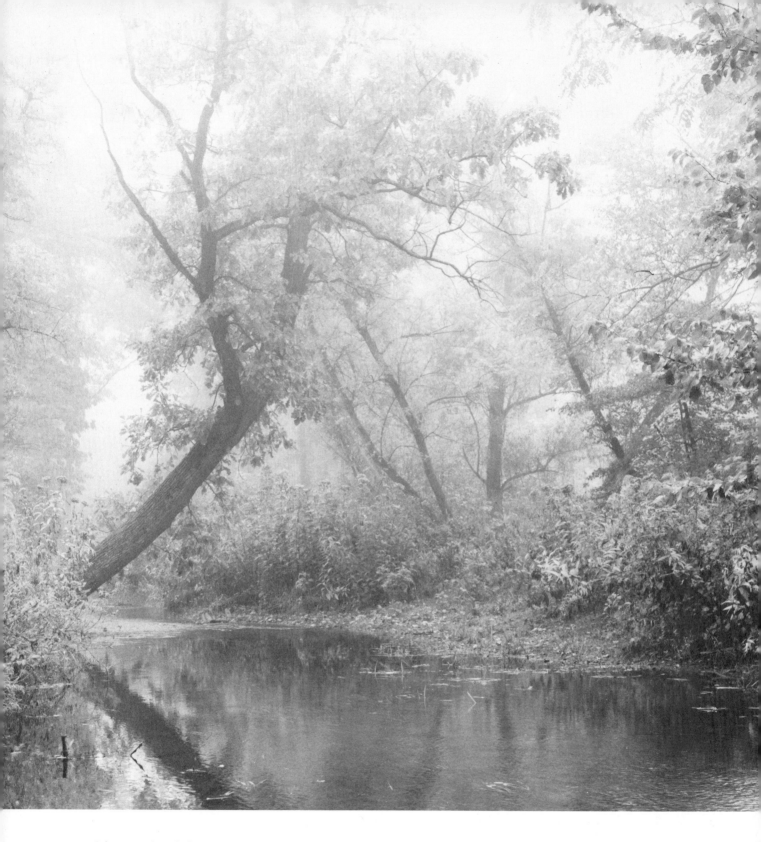

A foreground might have improved the photograph by directing the eye from no fog to all fog in the background.

Clouds and Sky

Work quickly when photographing clouds because their shapes constantly change. You may sometimes need a polarizing filter if the clouds are at an angle of 90 degrees from the sun. Generally, clouds have to be underexposed because they are bright subjects and look better when slightly darker. Try to include a horizon in cloud pictures in order to give a point of reference to the earth.

Using a cross-star filter is just too much "hand of man" for some critics even if it im-proves the composition. An alternative technique is to use a 28 mm or 20 mm wide-angle lens at $f/22$. If a tree or some other object stands between you and the sun, try maneuvering the camera so that the sun is cut off a little; the sunburst pattern is then increased. Stop down the lens using the preview button to protect your eye from the bright sun. This will also reduce the possibility of the lens concentrating the sunlight and burning a pinhole in a cloth shutter.

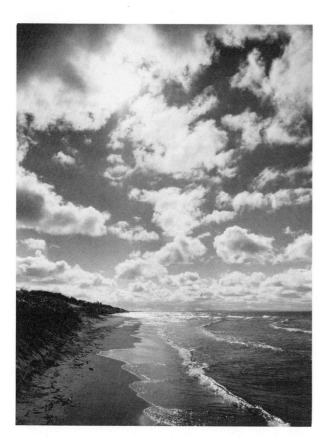

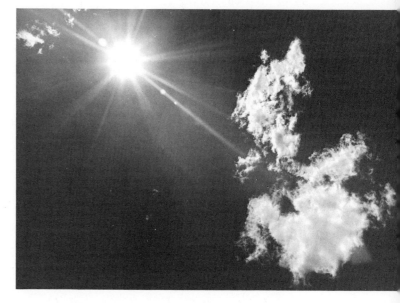

The photograph on the left was taken on a sunny day when many clouds were apparent. Bracketing produced an underexposed slide that shows the texture of the clouds. The sunburst above is at the "golden mean" position and was formed by using the lens at f/22. Remember to use your preview button when aiming the camera into a bright sun.

Herring gulls are the theme here, but the center of interest is the sunburst.

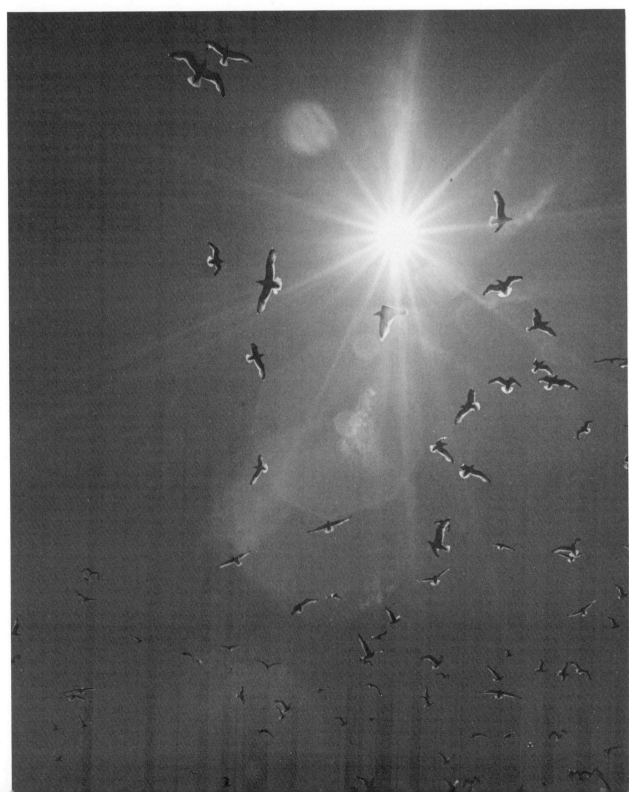

Sunsets

Sunsets can be photographed in almost any locale, but spectacular photographs are more easily achieved when a lake or large body of water is included in them. It is a good idea to choose a suitable vantage point during the day and return later for the actual event. Whether the sun and sky cooperate with your effort is a matter of luck.

A lens of almost any focal length can be used to photograph sunsets. The choice depends on the circumstances.

- A 200 mm lens records the sun as a spot $1/16$ inch in diameter on a 35 mm slide. This seems to be the appropriate size for the sun to appear when no clouds are shown.
- A 100 mm or 90 mm lens is useful when photographing the sun from a high vantage point and including most of the reflection from the water.
- A 50 mm lens is needed when clouds are present and the whole sky is brilliant with color.
- A 28 mm lens is handy when a sunburst is desirable or an expansive landscape is to be included.

The bare sun is bright in relation to matter surrounding it so you will need to underexpose by an amount determined through experimentation with your particular metering system. Take an exposure reading next to the sun and then underexpose, by $1/2$-stop increments, a series of five exposures. Select the best-exposed slide and use this same amount of underexposure for future sunsets. Exposure bracketing is often the only way to assure a properly exposed slide.

A sunset will change rapidly as the sun approaches the horizon. Under clear skies, you can actually see the sun move "into" an open body of water. You must work fast to record each change in color and intensity. Meter readings will have to be made almost constantly. Take the entire sunset sequence from start to finish to guarantee some good photographs.

By focusing on an object in front of the sun and keeping the sun itself extremely out of focus, you can achieve very unusual results. Use the lens wide open, or you will get the appearance of an unnatural five-sided sun from the diaphragm blades. An alternative is to use a short-mount lens with a round iris diaphragm mounted on a bellows. This allows you to stop down if necessary.

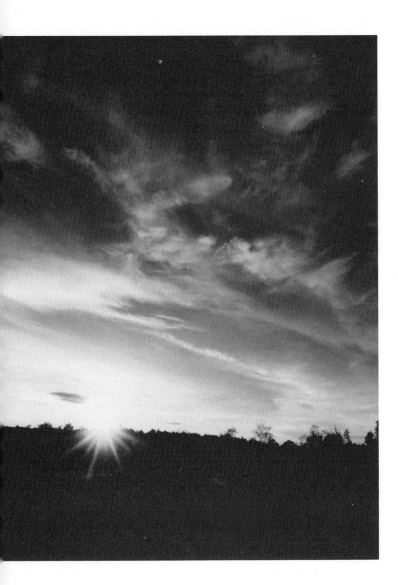

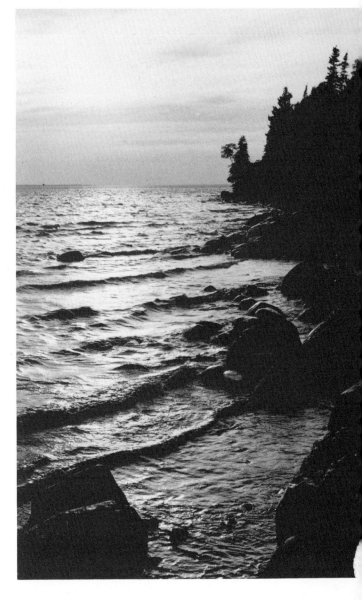

28 mm lens *The sunburst is the center of interest, but the shapes and color of the sky are equally important.*

50 mm lens *The setting sun gives the mood; the sky, water, and rocks carry the photograph to completion.*

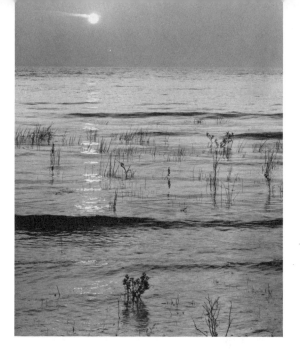

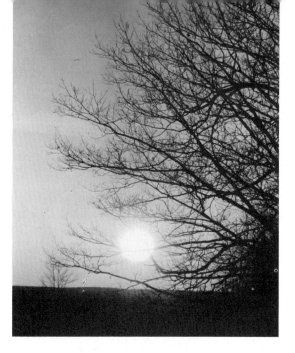

90 mm lens *A 90 mm-focal length lens is a favorite for many sunset situations.*

200 mm lens *A cloudless sunset is not very photogenic without something to fill the frame.*

135 mm lens *A 135 mm-focal-length lens mounted on a bellows was used for this sunset photograph of beachgrass. The lens should be stopped down only one or two f-stops as the sun will otherwise become very small.*

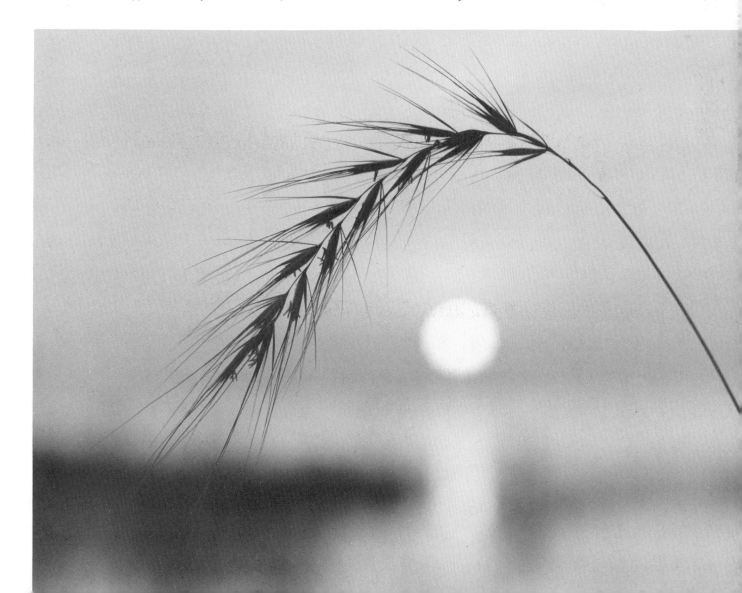

Overcast days present a real challenge with snow scenes. The trees and stream are combined with the snow to form a scene where nothing dominates. This is an example of diffused lighting. ▶

Snow

Sunlight is usually required to achieve a pleasing snow photograph. Without it, snow has no detail or shape. Morning and afternoon sunlight adds highlights to the snow by defining texture and shape. Exposure is difficult because some in-camera light meters read snow as gray and then underexpose the scene. The result is a photograph having gray snow. On a sunny day it is best to follow the directions that come packed with the film; for Kodachrome 25 an exposure of 1/125 sec. at *f*/8-11 would be optimum.

The rhythm of the shadows on the snow is the theme. Side lighting was used.

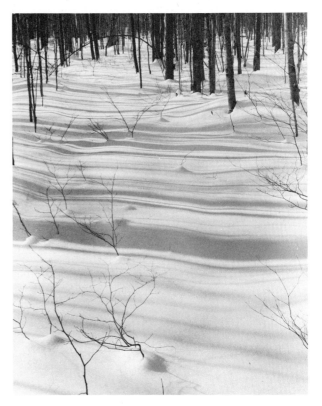

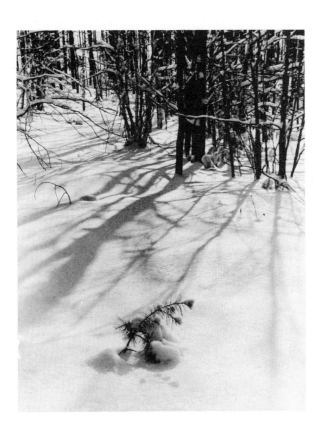

The small white pine is the center of interest, but the shadows on the snow form the theme. Back lighting was used here.

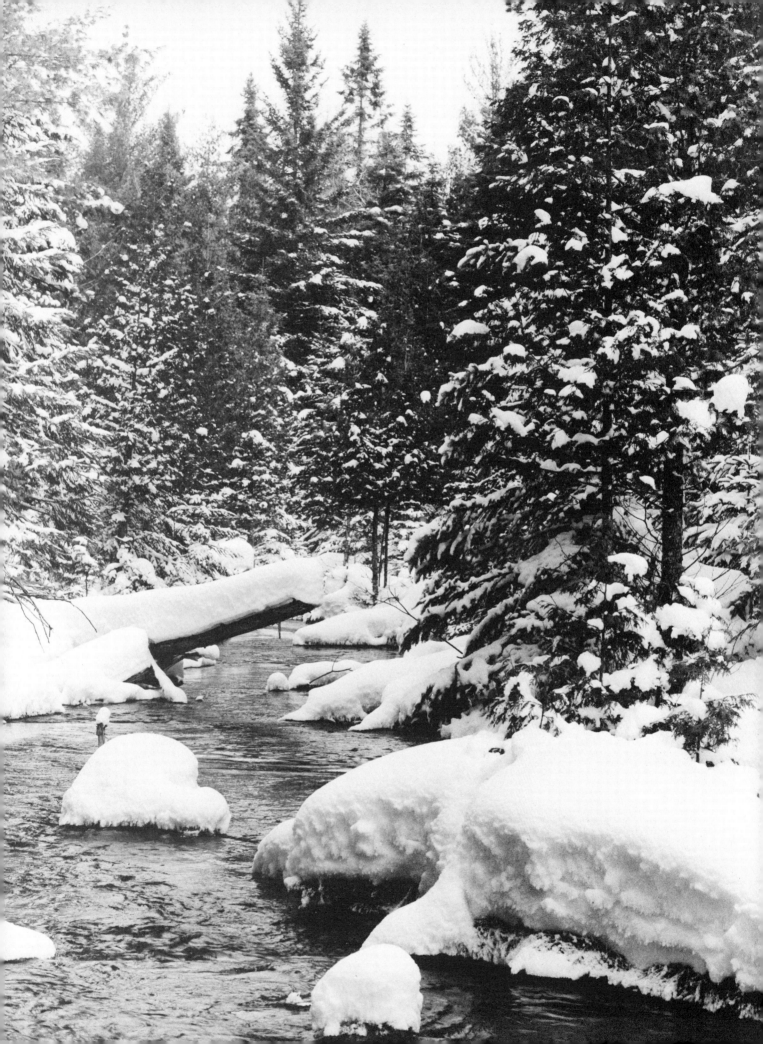

Waterfalls

You do not need Niagara Falls to make a good photograph of a waterfall. There are both large and small waterfalls that may be photographed; it may even be possible to move in close to a particular waterfall and isolate a segment that might be as small as a foot in height. Water must appear to be in motion and look fluid. This is achieved by using a shutter speed of 1/4 sec. or slower to show blurred water. If unsure about the effect, try a range of shutter speeds from one second to 1/60 sec. Many times when photographing a waterfall in a wooded area, you will have to use even longer exposure times, possibly of a second or more, because of low light intensities.

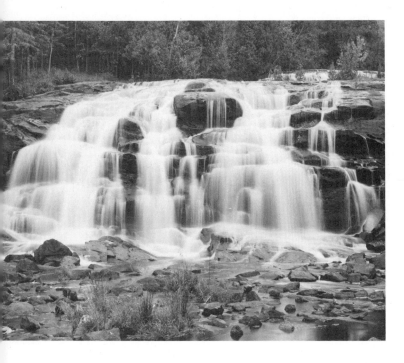

This is just part of the rather wide Bond Falls in Michigan. Note how three lines "cascade" down from the top. A dozen additional photographs of this scene could be made by moving closer.

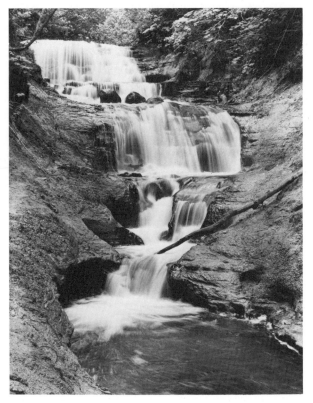

A ten-second exposure was required on a dark and rainy day. The waterfall seems almost abstract but this is how it really appeared.

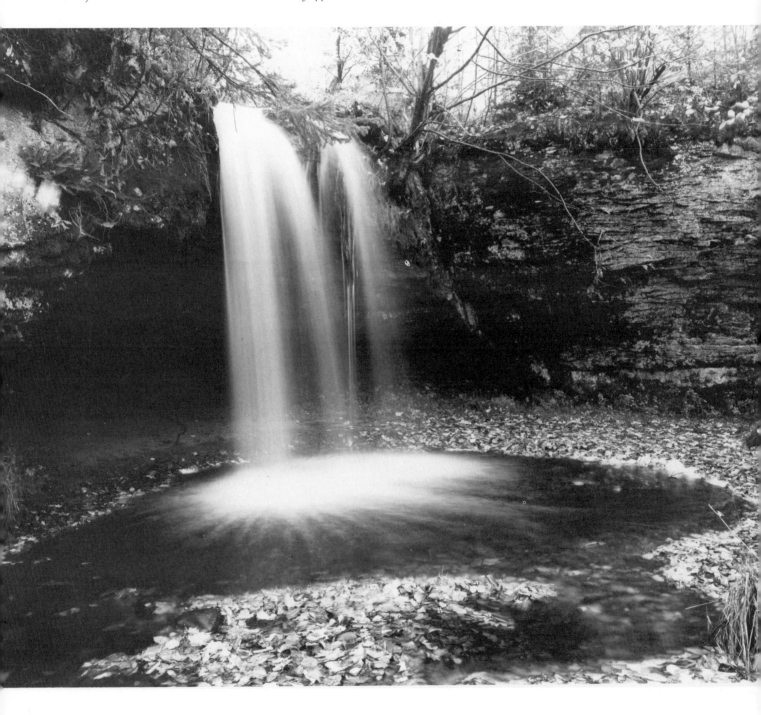

Lakeshore and Waves

At the shoreline, waves often crash onto rocks giving a sense of motion, time, and pattern. When photographing such a scene, be certain that the camera is parallel with the horizon so that the water does not appear to run down hill. Use of a 1/60 sec. shutter speed to show some wave motion and a frozen effect will reveal waves as they actually are. Watch for patterns and try to isolate one surfing wave. To capture water drops hanging in mid-air, try a shutter speed of 1/500 sec. as the waves crash onto rocks.

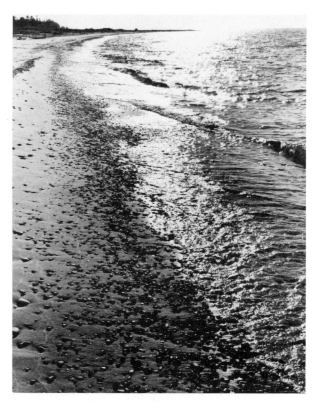

A shutter of 1/500 sec. caught the wave crashing over the rock. It is a matter of coordination and luck to capture the movement at the peak of action.

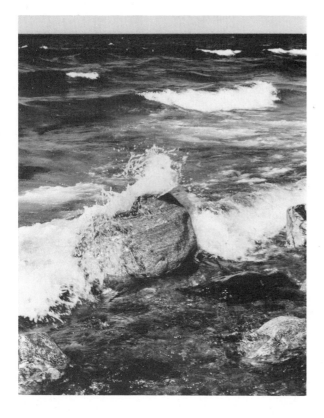

Extreme depth-of-field was needed to achieve overall sharpness.

Dew

Daybreak provides the only opportunity to photograph dew; shortly afterward the wind blows off the drops or the sun evaporates them. Dew is usually an extreme close-up subject. Try to catch the sun and horizon in the drop. Use *f*/22 if possible for maximum sharpness.

Dew often collects on the edge of strawberry leaves; isolate just one or two leaves so that the dew drops are visible.

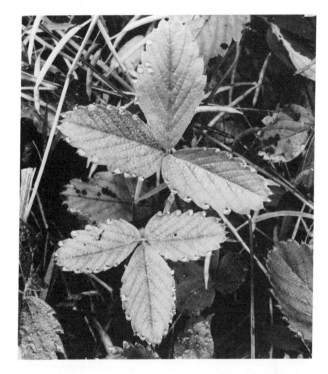

A single dew drop is enough for a dramatic photograph. Composition dominates: The diagonal of the blade of grass, nondistracting background, and the sunburst in the "golden mean" position all make for impact.

Rain

You need shutter speeds of 1/60 sec. or 1/125 sec. to stop rain splashing on water. Slower speeds result in meaningless blurs. The presence of rain can also be shown by raindrops that have fallen onto plants or flowers.

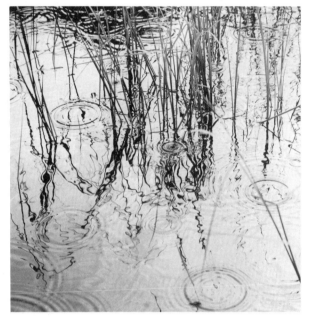

Many exposures will be needed to attain a satisfactory photograph of raindrops. The raindrops should be big and widely spaced; too much rain or small drops will be rendered as a blur.

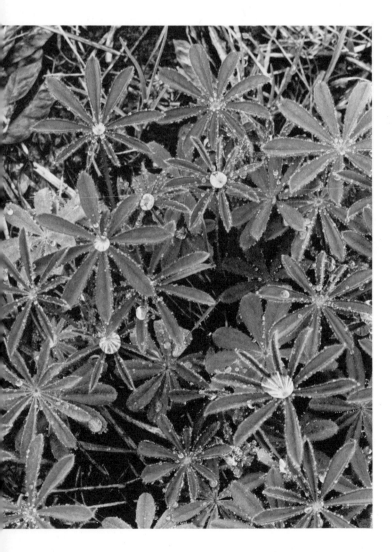

The water in this photograph had collected on the lupine leaves. Raindrops striking the leaves sometimes caused motion so a few exposures were made.

Animals in Zoos

For most of us, a zoo provides our only contact with large mammals and birds. However, the "hand of man" is often evident in zoos and its appearance in photographs must be avoided. A 400 mm long-focus lens helps to isolate the subject that is in an unnatural location.

Patience is often needed, since the subject may not be at a suitable spot or in a good position for composition. If it does not move into a proper setting, try again at a different time of day: morning, noon, evening, or perhaps at feeding time. When photographing an animal, remember that the eyes should be visible and sharp and, depending on the type of animal, should show a catch light.

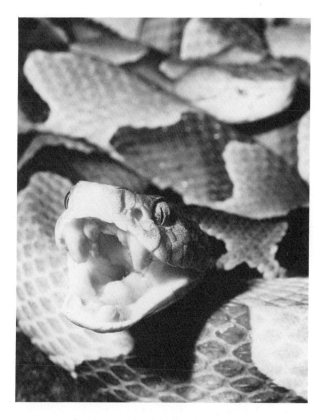

Although safely in a glass cage, the copperhead does not look very inviting. Photography through glass poses limitations but is not difficult; keep the lens near the glass to prevent reflections and as perpendicular as possible to reduce distortion. Hold an electronic flash unit at the 45-degree-angle position.

It was a matter of luck to catch this lion yawning at a zoo.

Butterflies

Your lens should be at least 90 mm so that you can fill the frame but remain some distance away from the subject. Move slowly toward the butterfly and stay low; insects are very suspicious of fast movements or shadows cast on them. Mornings are a good time to locate subjects, as butterflies are less active before the sun warms them. Look near fence rows, roadsides, and grassy fields. As butterflies are warmed by the morning sun, search for them on flowers such as milkweed or thistle, which grow in open fields. Mudpuddles sometimes attract certain butterflies. Many are not attracted to anything in particular, but wander aimlessly, occasionally alighting on plants or ground. Try walking along dirt roads, railroad tracks, or stream banks which act as flyways. Dusk is also a good time to look for butterflies since they slow down and seek a place to spend the night.

The "question mark" (left) is so named because of the silver marks on the underside of its wing. The species does not alight on flowers but can often be found flying along a sandy road.

The tiger swallowtail below is a common butterfly throughout much of the United States. Note the erect antenna and the tongue extended into the flower.

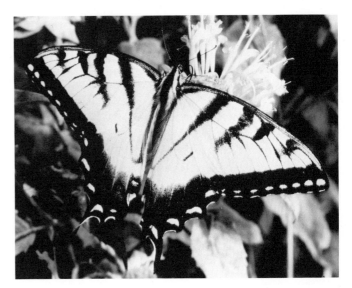

CHAPTER 10

Organization of Your Photographs

When your slides are returned from the processor, you still have plenty of work to do: previewing, labeling, evaluating, sorting, and cropping. This is the non-creative aspect of photography but, nonetheless, a very important one.

Preview

The preview is the initial evaluation of slides as they come from the processor. For this operation use a slide sorter and loupe. Go through the slides and discard those lacking sharpness, those at the ends of the film rolls, those severely over- or underexposed, and those just not worth keeping.

Initially the beginner does not have a reference point by which to evaluate slides. What is a properly exposed slide? It is one that records a full range of intensities from white to black or a full spectrum of colors from light to dark hues. The easiest way to obtain a reference slide is to expose Kodachrome 25 on a normally sunny day with an exposure of $f/8$ at 1/125 sec. Photograph a landscape that has a range of colors and intensities. Your reference slide will then give you an indication of how a properly exposed slide should look when projected.

Labeling

With the remaining slides you can use a rubber date stamp and indicate the day on which the photographs were made. Then add the location below the date, including information that will enable you to return to the same area if need be. This might be a national, state, or local park, a particular geographic location, or a city or county.

If you keep a notebook, transfer the exposure information to the slide. It is important to identify the subject: Include, for instance, the name of a waterfall, river, mountain, plant, or tree. Do not rely on memory for names since they might become unclear by the time you receive the processed slides.

Many photographers like to "spot" each slide with a mark on the lower left corner of the mount to indicate the correct orientation for viewing. Use a new pencil eraser and a stamp pad for this operation.

Selection Process

Now you can select the best of any bracketed exposures or the best of a series covering a particular subject. You can decide which experiments were successful. Mediocre and poor slides can be filed away by date, subject, or location.

Your Best Slides

The remaining slides can now be shown to friends, presented in slide lectures, or used in photography exhibitions. Hopefully there will be some slides that meet your highest expectations for photographic art. There may not be many—perhaps 1 or 2 from a 36-exposure roll—but this is normal.

Your very best examples of nature photography should be kept in a separate file so that they will be readily available for whatever occasion arises. You can begin breaking slides down by subject category as the volume of slides of a particular subject increases.

SUGGESTED FILING SYSTEM

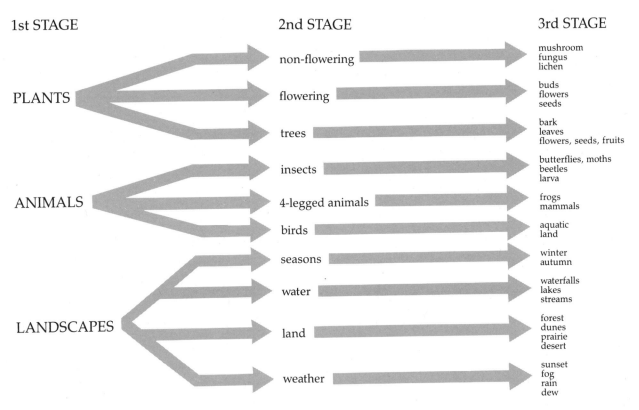

1st STAGE	2nd STAGE	3rd STAGE
PLANTS	non-flowering	mushroom fungus lichen
	flowering	buds flowers seeds
	trees	bark leaves flowers, seeds, fruits
ANIMALS	insects	butterflies, moths beetles larva
	4-legged animals	frogs mammals
	birds	aquatic land
LANDSCAPES	seasons	winter autumn
	water	waterfalls lakes streams
	land	forest dunes prairie desert
	weather	sunset fog rain dew

Slide Masking

Often certain compositional elements are not fully apparent until the finished slide is viewed. You may then realize that the subject should be isolated, that the frame should be filled, or that distractions should be eliminated. Masking a slide by using openings of various shapes and sizes can go a long way toward improving the final result.

Remove the slide from its mount. Use the mask selector (shown here) to locate a suitable opening. Remove the paper backing from a pressure-sensitive mount and place the slide on the adhesive side. Close the mount and the slide is ready for projection.

Appendix

THE NATURE PHOTOGRAPHER'S CODE OF PRACTICE

"The welfare of the subject is more important than the photograph."

Your conduct in a natural area should be such that the risk of physical damage, potential predation, or reduced reproductive capacity of a species is kept to a minimum. The amount of acceptable risk decreases with the scarcity of the species. Thus your presence should result in as little change in the environment as possible.

Your efforts in nature photography should be within the following restraints:

Birds at nest

Complete knowledge of a species' breeding behavior should be known before attempting photography at nests. Practice with a common species before attempting something rarer. House cleaning around the nest should be at a minimum so as not to expose the subject to predators, people, or adverse weather. Tying back instead of cutting off interfering foliage is preferred. If it is apparent that your presence is threatening the safety of the birds, you should pack up and leave.

Use of either a stuffed predator to incite an alarm reaction or tape recording to stimulate territorial reaction should not be directed towards an active nest.

Mammals or non-nesting birds

Capture of wildlife for photography is hardly justified. Not only is the wild subject difficult to handle, it inevitably will end up with a frightened and cornered look in the photograph.

Other animals

Cold-blooded animals and invertebrates are often captured and photographed later in a terrarium or other setup. The specimen should be kept for only a day and then returned to the site of capture. Most creatures do not readily accept food after capture thus making them unsuitable as pets. It is a better practice to undertake photography immediately after capture.

Handling of the subject should be at an absolute minimum. If possible, allow the subject to move around by placing appropriate props on which to climb.

Chilling or light anaesthesia is not recommended as the subject almost always shows the effects of such treatment. If such a procedure is undertaken, the subject should be released only after the effects have worn off and then only to the area of capture. Taking a subject home and forcing it to pose is likely to result in its death.

Rocks or logs that are overturned in search of subjects should be returned to their original position. This will allow you to search again at a later time.

Plants

It is often very tempting to dig up an especially attractive plant without realizing that if

everyone were so selfish, the species could disappear from an area for others to enjoy.

No plant should be picked or dug up to be later photographed at home. Nor should a plant be removed in order to facilitate the photographing of another.

General

Your photographic efforts in a nature sanctuary should be with the attitude that you are intruding into someone's home. Stay on established nature trails, or if none exist, step carefully to avoid obscure plant life.

While setting up your equipment, be aware of the plant life around you so as not to trample them down. Trampling of almost any natural habitat can kill or reduce delicate species.

In conclusion

By subscribing to a code of practice, nature photographers can show that they are a concerned and responsible group of naturalists who have a positive contribution to make in the cause of conservation.